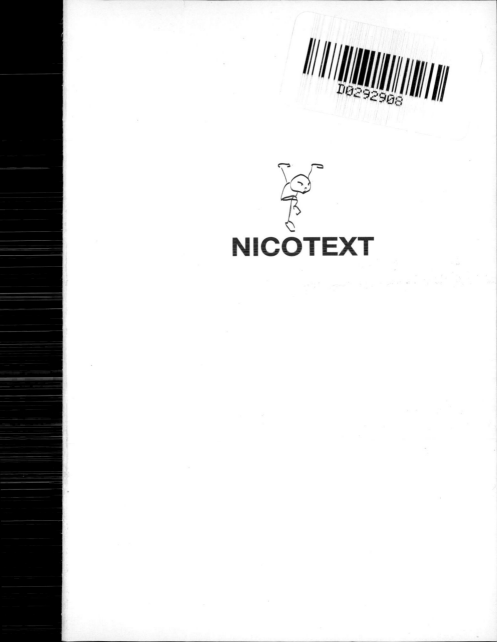

NICOTEXT

Ultra Modern History

The Legal Text
Look here, dude, this book is ours. We made it, and we own it.
We therefore forbid you to do any of the following with it:
use the pages as toilet paper, use the book as a meal tray,
reproduce any part of this book without written permission from the
Publisher (that would be us).
If you ignore this warning we will get really, really upset with
you. That, and we'll put a snail on your eye while you're
sleeping. So, if you don't want a snail on your eye, do as we say! Now,
lean back and enjoy this here book we put together,
just for you.

DO NOT DRINK AND DRIVE & DO NOT DRINK ALCOHOL
IF YOU ARE UNDER DRINKING AGE!

...AND KIDS, REMEMBER, ALWAYS WEAR A CONDOM!

The publisher, authors disclaim any liability that may result
from the use of the information contained in this book.

All the information in this book comes directly from experts but we
do not guarantee that the information contained herein is complete
or accurate.

www.nicotext.com
info@nicotext.com

Fredrik Colting
Carl-Johan Gadd

Index

BODY

Body Building

Bodybuilding can be traced back to the 11th century in India where athletes created their own dumbbells out of stone and wood.

Bodybuilding did not really gain popularity in the West until the late 19th century, when the sport was promoted by the German Eugen Sandow - who is now often referred to as the "Father of modern bodybuilding". He is credited with inventing and selling the first machine made dumbbells. Sandow organized the first ever bodybuilding contest on September 14, 1901 called the "Great Competition" and held in the Royal Albert Hall in London. Judged by himself, Sir Charles Lawes, and Sir Arthur Conan Doyle the contest was a huge success with hundreds of fans turned away. The trophy presented to the winner was a bronze statue of Sandow himself sculpted by Frederick Pomeroy. This statue (known as "The Sandow") has been presented to the Mr. Olympia winner since 1977.

The period of around 1940 to 1970 is often referred to as the "Golden Age" of bodybuilding. In this period bodybuilding was typified by Muscle Beach in Santa Monica, California.

Boob Jobs

Breast implants have been used at least since 1865 to augment the size of women's breasts.

The earliest known implant occurred in Germany in which fat from a benign tumor was removed from a woman's back and implanted in her breast. In following years the medical community experimented with implants of various materials, most commonly paraffin.

The first use of silicone as breast-implant material may have been by Japanese prostitutes in the period immediately following World War II, who would directly inject the silicone into their breasts.

Houston plastic surgeons Thomas Cronin and Frank Gerow developed the first silicone breast prosthesis with the Dow Corning Corporation in 1961 and the first woman was implanted in 1962. The implant was made of a silicone rubber envelope filled with a thick, viscous silicone gel.

The Gym

Gyms can be traced back to the 11th century in India where there is evidence that athletes created the first gyms.

The first modern gyms, or gymnasiums, were started by schools and colleges. The first college gymnasium was built at Harvard University in 1820. The movement of going to the gym first appeared in Germany where it was promoted by German educator Friedrich Jahn and the Turners, a nineteenth-century political and gymnastic movement.

In the United States, the Turner movement thrived in the late nineteenth and early twentieth centuries. The Turners built gymnasiums in several cities like Cincinnati and St. Louis which had large German American populations.
These gyms were utilized by both adults and youth.

Later, The Young Men's Christian Association (YMCA), first organized in Boston 1851, provided gymnasiums for exercise and games as well as a safe haven for troubled youth.

Pamela Anderson

Pamela Anderson is a Canadian international television actress, model and a producer. She was the sex symbol of the Western world during the 1990's.

Pamela Denise Anderson was born on July 1, 1967 in Lady-smith, British Columbia, Canada of partially Finnish ancestry. As the first baby born on Canada's Centennial Day, the new-born Anderson won fame as the nation's "Centennial Baby". After her birth, her parents Barry and Carol Anderson moved to the town of Comox with baby Pamela.

Besides being the sex symbol of the Western world during the 1990's she has been on the cover of Playboy Magazine, starred in the TV series Baywatch and in the motion picture Barb Wire.

FUN FUN FUN

During the 1990's Pamela Anderson was the
most searched person on the internet.

Piercing

Body piercing (including ear piercing) has been practiced by peoples all over the world from ancient times. Mummified bodies with piercings have been discovered, and nose piercing and ear piercing are even mentioned in the Bible.

Women in India routinely practice nostril piercing, and have done so for centuries. Nipple piercing became popular in 14th century Europe, invented initially by the Romans.

Tongue piercing was popular with the elite of Aztec and Maya civilization, and ancient Mesoamericans wore jewelry in their ears, noses, and lower lips. Such decorations continue to be popular amongst indigenous peoples in these regions, as well as young people of all cultures.

FACTS FACTS FACTS

In 1975, Jim Ward opened The Gauntlet, America's first storefront body piercing operation, in Los Angeles.

Plastic Surgery

The history of cosmetic surgery spans back to the ancient world. The Romans were able to perform simple techniques such as repairing damaged ears. Physicians in ancient India were utilizing skin grafts for reconstructive work as early as 800 B.C and performed nose reconstruction, using a portion of the forehead, during periods where amputation of the nose was a punishment for certain crimes.

In mid-15th century Europe, Heinrich von Pfolspeundt described a process "to make a new nose for one who lacks it entirely, and the dogs have devoured it" by removing skin from the back of the arm and suturing it in place. However, because of the dangers associated with surgery in any form, especially that involving the head or face, it was not until the 19th and 20th centuries that such surgeries became commonplace. The U.S.'s first plastic surgeon was Dr. John Peter Mettauer. He performed the first cleft palate operation in 1827 with instruments that he designed himself.

The 'Rachel'

The 'Rachel' cut, was a huge fad during the 1990's. Jennifer Aniston's character in 'Friends' had hair that was long and sleek with longer length layers, a 'grown-out' fringe and framed with highlights around the face.

Tattoos

Tattooing has been a practice of almost every culture ever since Neolithic times. "Ötzi the Iceman", circa 3300 BC, exhibits tattoos (small parallel dashes along lumbar and on the legs).

The Ainu, the indigenous people of Japan, wore facial tattoos, and tattooing was widespread among the Polynesians, as well as the Philippines, Borneo, Samoa, Africa, Mesoamerica, Japan, and China.

Europeans rediscovered tattooing during the exploration of the South Pacific under Captain James Cook in the 1770s. Sailors were particularly identified with tattoos in European culture until after World War I.

FACTS FACTS FACTS

The modern electric tattoo machine is fundamentally the same machine invented by Samuel O'Reilly in 1891, which was based on an electric engraving pen invented by Thomas Edison.

CULTURE

The Finger

The origins of this gesture is quite possibly 2500 years old. It is identified as the digitus impudicus ('impudent finger') in Ancient Roman writings.
It was defined there as a gesture intended to insult another. It has been noted that the gesture resembles an erect penis.

A popular story about the origin of the finger refers to the gestures of Welsh longbowmen fighting for the English against France. The French cut off fingers from captured archers, usually the index and middle finger of the right hand, and according to this tale, the finger was a sign of defiance by those who retained their fingers, and thus could still shoot.

Fuck

Its first known use as a verb meaning to have sexual intercourse is in the poem "Flen flyys" some time before 1500, which reads "They [the friars] are not in heaven, since they fuck the wives of Ely". While Shakespeare never used the term explicitly, he hinted at it in comic scenes in several plays.
In 1971, the U.S. Supreme Court decided that the mere public display of fuck is protected under the First and Fourteenth Amendments and cannot be made a criminal offense.

Fuck first appeared in the Oxford English Dictionary (along with the word cunt) in 1972. The first short story to include fuck in its title was probably Kurt Vonnegut's "The Big Space Fuck", originally published in 1972.

Famous Fucks

In 1900, Albert Edward, Prince of Wales said, "Fuck it, I've taken a bullet" when he was shot while standing on a Brussels railway station.

In a widely-publicized June 2004 incident, US Vice President Dick Cheney told Senator Patrick Leahy to either "fuck off" or "go fuck" himself during an exchange on the floor of the Senate. The Washington Times, in a show of journalistic prudence, reported that the Vice President "urged Mr. Leahy to perform an anatomical sexual impossibility."

Irony

A form of modern irony, so called Socratic irony, dates back to Socrates, 400 BC.
As Cicero put it, Socrates was always "pretending to need information and professing admiration for the wisdom of his companion", when Socrates' interlocutors were annoyed with him for behaving in this way they called him eiron, a vulgar term of reproach referring generally to any kind of sly deception with overtones of mockery.
The fox was the symbol of the eiron.

New words – Cool

"Cool" has its roots in Middle English "cole", from Old English "col" indicating "aloofness, composure and absence of excitement" in a person, especially in times of stress.
The modern usage of "cool" as a general positive epithet or interjection has been part of English slang since World War II, and has been incorporated into other languages, such as French and German. Use of the term in this manner has its origin in African-American slang, having first been recorded in written English in the early 1930s.

New words – "What's up?"

What's up is an informal expression meaning "what are you doing?", "how are you?", or "what gives?". It is often shortened to "sup," "wussup," "wutsup," or "wassup."
It is unclear as to what the origin of the term is.

This expression was made very popular by the cartoon Bugs Bunny who used it as part of his catch phrase "What's up, Doc?". It gained more notoriety when it was used in a series of beer commercials in the early 2000s.

TRIVIA TRIVIA TRIVIA

Among Mexican-American street gangs in California, the phrase "what's up" means "there's going to be a fight" when opposing rival gangs confront each other.

New words - Yo

In the English language, 'yo' has become a common interjection that originated decades ago in a dialect spoken in the Philadelphia area. It is often interchangeable with the word "hey," as in "Yo, what's up?" or, "Yo! Wait for me!" While the word can also stand alone as a greeting. Like the word "hey," it also has a wide range of meanings that depend on the tone, context, and situation in which it is used.

QUOTES QUOTES QUOTES

"Yo, Adrienne, it's me, Rocky..."
Rocky Balboa (Rocky, 1976)

Pets – Cats

The earliest written records of attempts to domesticate cats date back to ancient Egypt, circa 4000 BC, where cats were employed to keep mice and rats away from grain stores. However, statues from Anatolia created around 6000 BC have also been found depicting women playing with domesticated cats, which implies that cats were domesticated there around the same time period.

Ancient Egyptians regarded cats as embodiments of the goddess Bast, the guardian of Lower Egypt, and the penalty for killing a cat was death, and when a cat died it was sometimes mummified in the same way as a human. Even the Vikings used cats as rat catchers and companions. The Viking goddess of love, fertility and war, Freya, was strongly associated with cats, as they were considered her sacred animals.

Pets – Dogs

The gray wolf is the most probable
ancestor of all current dog breeds.

The first demonstrable signs of relationships between
man and wolves date back to 10.000 to 15.000 years ago.

Man used wolves during the hunt, for keeping flocks together
and to warn against approaching enemies. Man in turn, made
sure his wolves were fed.

Wolves are very social animals. Like humans, they live in
groups (called packs) with social ranks, in which some wolves
claim leadership. This made the animal suitable and
attractive as a companion, because wolves accepted
man as their leader.

During the Middle Ages, people started seeing dogs as status
symbols. Dogs gave people distinction. The number of dog
breeds started to increase enormously. Dogs were bred for
size, length, color, face, behavior and fur texture. These were
the predecessor to modern dogs.

Profanity

Terms of profanity have historically been taboo words,
meaning, words that are usually considered objectionable
or abhorrent by society.
The offensiveness or perceived intensity or vulgarity of the
various profanities can change over time, with certain words
becoming more or less offensive as time goes on.

Psycholinguistic studies have demonstrated that profanity
and other taboo words produce physical effects in people
who read or hear them, such as an elevated heart rate.

New Words - Shit

"Shit" was originally adopted into Old English as "scitte", eventually morphing into Middle English "schitte".

The variant form "shite" is found in many regional and social dialects, especially in Scotland, Ireland and Northern England, and is sometimes used in other parts of the world as a less-offensive (at least in intent) form of the word "shit". Shite can also be used by people in North America to sound funny, as it is not usually used.

Spoken and written substitutes for the word shit in American English include sugar, "shizer", sheesh, shoot, and shucks, as in the constructions "oh, sugar!", "sheesh", "that was a close one", "aw, shoot", and "shucks".

In the United Kingdom and Ireland, "bollocks" is often used as a coarse but nowhere near as offensive substitute.

TRIVIA TRIVIA TRIVIA

The surname "Shitz" appears to be abandoned, as any individual who held it would find their first name unwillingly and irrevocably engaged in a grammatical but unflattering sentence.

Smileys

September 19, 1982, the computer scientist, Scott Fahlman from the Carnegie Mellon University, Pittsburgh, USA was the first to suggest the use of a smiley, or emoticon, as a way of expressing sarcasm of irony in emails.

Fahlman's 1982 message posted on a university message board has gone down in internet folklore as the year zero of smiley language. :-)

The emoticon has become so popular that an Emoticon News Bureau has been created to monitor events in the world of the smiley. :~/

Yet despite this momentous invention, Fahlman has never made a penny from it. He did not realize what a popular new language he had invented on that September day, and so never thought to patent it or even to keep a record of the day himself.

:-(

The Smiley Man

The smiley face so popular in the 60s and 70s was invented by Harvey Ball in 1963 for the Worcester, Massachusetts based insurance firm, State Mutual Life Insurance.
There was an attempt to trademark the image, but it fell into the public domain before that could be accomplished.

The graphic was popularized in the early 1970s by a pair of brothers, Murray and Bernard Spain, who seized upon it in a campaign to sell novelty items. The two produced buttons as well as coffee mugs, t-shirts, bumper stickers and many other items emblazoned with the symbol and the phrase "Have a Nice Day" (devised by Murray). By 1972 there were an estimated 50 million "smiley" buttons throughout the U.S., at which point the fad began to subside.

DRUGS

Aspirin

In 1897, the German chemist Felix Hoffmann, produced a stable form of acetylsalicylic acid, more commonly known as aspirin. Hoffmann, was searching for something to relieve his father's arthritis.

Birth Control

During the 1930s, it was discovered that hormones prevented ovulation in rabbits.

In 1950, Margaret Sanger, a lifelong advocate of women's rights, underwrote the research necessary to create the first human birth control pill and raised $150,000 for the project.

The birth control pill was introduced to the public in the early 1960s. Birth control pills are synthetic hormones that mimic the way real estrogen and progestin works in a women's body. The pill prevents ovulation - no new eggs are released by a women on the pill since her body is tricked into believing she is already pregnant.

FACTS FACTS FACTS

Frank Colton was the inventor of Enovid, the first oral contraceptive, and Carl Djerassi was the inventor of modern oral contraceptives, or simply the pill.

Botox

The German physician and poet Justinus Kerner first developed the idea of a possible therapeutic use of botulinum toxin, which he called "sausage poison." In 1895, Emile Van Ermengem first isolated the bacterium Clostridium botulinum. In 1944, Edward Schantz cultured Clostridium botulinum and isolated the toxin, and, in 1949, Burgen's group discovered that botulinum toxin blocks neuromuscular transmission.

Throughout the 1950s, the toxin was used experimentally in the medical cosmetic treatment of politicians. Then actor-turned-politician Ronald Reagan is rumoured to be one of the earliest patients of this microexpression-concealing procedure.

First by 2002, the FDA announced the approval of botulinum toxin type A (BOTOX® Cosmetic) to temporarily improve the appearance of frown lines between the eyebrows (glabellar lines).

Cigarettes

Tobacco was first used by the peoples of the pre-Columbian Americans. Native Americans cultivated the plant and smoked it in pipes for medicinal and ceremonial purposes.

Christopher Columbus brought a few tobacco leaves and seeds with him back to Europe, but most Europeans didn't get their first taste of tobacco until the mid-16th century, when adventurers and diplomats like France's Jean Nicot - for whom nicotine is named - began to popularize its use. Tobacco was introduced to France in 1556, Portugal in 1558, and Spain in 1559, and England in 1565.

The first successful commercial crop was cultivated in Virginia in 1612 by Englishman John Rolfe. Within seven years, it was the colony's largest export.

At first, tobacco was produced mainly for pipe-smoking, chewing, and snuff. Cigars didn't become popular until the early 1800s. Cigarettes, which had been around in crude form since the early 1600s, didn't become widely popular in the United States until after the Civil War.

Cocaine

Chewing on Coca leaves for the elevation of mood, to stimulate tired workers, and to produce euphoria, have been used for thousands of years in Central and South America.

In the mid-nineteenth century the United States and Europe took note of it's seemingly beneficial properties and began to extract it's principal active ingredient and made cocaine available as a water-soluble powder. It was discovered by physicians that the drug had potential use as an antidepressant, an asthma remedy and as a local anesthetic.

Toward the late nineteenth century cocaine began to be marketed as a recreational drug by such corporations as Coca-Cola, who claimed the seemingly mild intoxicant could be used as a "temperance beverage" as an alternative to booze.

At the dawn of the twentieth century, anti-cocaine legislation grew considerably. People began to see the rise of violence among abusers of the drug, and a rise in the awareness of cocaine's harmful physical effects. The first Federal Legislation regarding cocaine was with the 1906 Pure Food and Drug Act that required products precisely label the content therein. And in 1914, the United States Congress passed the Harrison Act, which imposed taxes on products containing cocaine. Soon, Drug Enforcement Officials quickly transformed the law to prohibit all recreational use of cocaine.

Ecstacy

A patent for 3,4-methylenedioxymethamphetamine, MDMA or Ecstacy, was originally filed on Christmas eve 1912 by the German pharmaceutical company Merck. At the time, MDMA was not known to be a drug in its own right; rather, it was patented as a drug intended to control bleeding from wounds. Over half a century would pass before the first known ingestion of MDMA by humans.

In the 1960s, Dr. Alexander Shulgin recommended it for use in certain therapy sessions, naming the drug 'window'.
The drug was hailed as a miracle by therapists and counselors and became widely used therapeutically by US psychothera-pists because of its empathogenic effects until its criminaliza-tion in 1985.

Recreationally, it first came into prominence in certain trendy yuppie bars in the Dallas area, then in gay dance clubs. From there, use spread to rave clubs, and then to mainstream society. During the 1990s, along with the growing popularity of the rave subculture, MDMA use became increasingly popular among young adults in universities and it rapidly became one of the four most widely used illegal drugs in the US, along with cocaine, heroin and marijuana.

Prozac

Prozac is the registered trademarked name for "fluoxetine hydrochloride" and the world's most widely prescribed antidepressant to-date. Prozac was first introduced to the US market in January 1988, and it only took two years for Prozac to become the market leader.

The team of inventors behind Prozac was lead by Ray Fuller. Fuller was posthumously awarded the Pharmaceutical Discoverer's Award from Narsad for discovering fluoxetine or Prozac. Also awarded were Bryan Molloy and David Wong, both members of the Eli Lilly Company research team.

Viagra

Viagra, or Sildenafil Citrate,
is the first medicine to treat impotence.

The medical company Pfizer claims that hundreds of
inventors were involved with the creation of Viagra, thus
making it impossible to point out one sole inventor.
According to the British press, Peter Dunn and Albert Wood
both of Kent, England are named as the inventors of the proc-
ess by which Viagra was created. Their names appeared on
an application by Pfizer to patent the manufacturing process
of Viagra.
In 1991, the three other Pfizer inventors Andrew Bell,
Dr. David Brown and Dr. Nicholas Terrett discovered that
chemical compounds were useful in treating heart problems
such as angina. Terrett was named in the 1991 British patent
for Sildenafil (trade named "Viagra") as a heart medicine, and
some experts consider him as the father of Viagra.

By 1994, Nicholas Terrett and colleague Peter Ellis discovered
during the trial studies of Sildenafil as a heart medicine that it
also increased blood flow to the penis, allowing men to
reverse erectile dysfunctions.
Dunn and Wood then worked on the crucial nine-step process
to synthesize a Sildenafil (Viagra) compound into a pill. It was
approved by the FDA on March 27, 1998, as the first pill to
treat impotence.

Dr. Simon Campbell, who until recently was the Senior Vice
President Of Medicinal Discovery at Pfizer and oversaw
Viagra's development, is considered by the American
press to be the inventor of Viagra.

Vitamins

The value of eating certain foods to maintain health was recognized long before vitamins were identified. The ancient Egyptians knew that feeding a patient liver would help cure night blindness, now known to be caused by a vitamin A deficiency, and in 1747, the Scottish surgeon James Lind discovered that citrus foods helped prevent scurvy.

1906 Frederick Hopkins postulated that foods contained "accessory factors" - in addition to proteins, carbohydrates, fats - that are necessary to the human body.
When Casimir Funk isolated the water-soluble complex of micronutrients, he proposed that it be named "Vitamine". The name soon became synonymous with Hopkins' "accessory factors". In 1920, Jack Cecil Drummond proposed that the final "e" be dropped, to deemphasize the "amine" reference, after the discovery that vitamin C had no amine component, and the name has been "vitamin" ever since. Throughout the 1900s, scientists were able to isolate and identify all vitamins known today.

Vitamin C

In 1747, Scottish naval surgeon James Lind discovered that an nutrient in citrus foods prevented scurvy. The nutrient was Vitamin C. It was the first vitamin to be artificially synthesized in 1935. A process invented by Dr. Tadeusz Reichstein, of the Swiss Institute of Technology in Zurich

TRAVEL

Backpacking

Where the original idea of backpacking originated from is lost in the midsts of time. Perhaps the cave man or other prehistoric creature decided to walk along with a "pack" on their backs containing their food and other necessary items.

Hiking has long been used as an exercise in military training programs but hiking has also become a popular recreational activity. In the US the National Scenic Trail Act of 1968, which made large tracts of land available to the public for recreational use, contributed greatly to the growth of hiking as a pastime. The act helped to set up a system of hiking trails that runs throughout the country.

Frequent Flyer Miles

A Frequent Flyer Program is a service offered by many airlines to reward customer loyalty. The first, and still largest, frequent flyer program is AAdvantage, sponsored by American Airlines, launched May 1, 1981. Accrued points, frequent flyer miles, can be redeemed for free air travel and other products or services.

Low Fare Airlines

The first successful low-cost carrier was Pacific Southwest Airlines in the United States, which pioneered the concept when their first flight took place on May 6, 1949. With the advent of aviation deregulation the model spread to Europe as well, the most notable successes being Ireland's Ryanair, which began low-fares operations in 1991, and easyJet, formed in 1995.

COMMUNICATION

911

The ability to dial a single number to report emergencies was first used in Great Britain, in 1937. The British could dial 999 to call for police, medical or fire departments from anywhere in the country.

The very first American 911 call was placed on February 16, 1968 in Haleyville, Alabama. It was made by the Alabama Speaker of the House, Rankin Fite, and answered by Congressman Tom Bevill.

The new emergency number had to be three numbers that were not in use in the United States or Canada as the first three numbers of any phone number or area code, and the numbers had to be easy to use.

Bob Gallagher, President of Alabama Telephone, decided to beat AT&T and have the first 911 emergency service built in Haleyville, Alabama. Gallagher and Bob Fitzgerald, his state inside-plant manager, worked around the clock to install the first 911 emergency system in under one week.
The work was completed on February 16, 1968, at exactly 2 p.m. and celebrated with a team cheer of "Bingo!"

E-Mail

E-mail is defined as "the ability to send simple messages to another person across a network".

E-mail was invented by computer engineer, Ray Tomlinson, in late 1971. Ray Tomlinson worked as a computer engineer for Bolt Beranek and Newman (BBN), the company hired by the United States Defense Department to build the first Internet in 1968.

Ray Tomlinson was experimenting with another program he wrote, called SNDMSG, that the ARPANET programmers were using on the network computers to leave messages for each other.

Ray Tomlinson chose the "@" symbol to tell which user was "at" what computer.

TRIVIA TRIVIA TRIVIA

The first e-mail message ever sent was "QWERTYUIOP" and was sent between two computers that were actually sitting next to each other.

Freeways

The concept of highways dates back to the New York City area Parkway system, which began to be constructed in 1907–1908. Designers elsewhere also researched these ideas, especially in Germany, where the Autobahn became the first national freeway system.

The term "freeway" first surfaced in the mid-1930s and the first true freeway in the United States was the Pennsylvania Turnpike, which opened on October 1, 1940.

Shortly thereafter, on December 30, 1940, California opened its first freeway, the Arroyo Seco Parkway (the Pasadena Freeway) which connected Pasadena with Los Angeles.

TRIVIA TRIVIA TRIVIA

When the Pennsylvania Turnpike opened it was so advanced for its time that tourists had picnics in the median.

HTML

Tim Berners-Lee invented the World Wide Web, HTML, HTTP and URLs in 1990. He was assisted by his colleagues at CERN, an international scientific organization based in Geneva, Switzerland.

FACTS FACTS FACTS

HTML stands for "hypertext markup language".

Java Script

JavaScript was created by Netscape programmer Brendan Eich. The web scripting language was first released under the name of LiveScript as part of Netscape Navigator 2.0 in September 1995. It was renamed JavaScript on December 4, 1995.

The Internet

In 1969, work began on the ARPAnet, grandfather to the Internet.

The ARPAnet protected the flow of information between military installations by creating a network of geographically separated computers that could exchange information via a newly developed protocol called NCP.

The first data exchange over this new network occurred between computers at UCLA and Stanford Research Institute. Four computers were the first connected in the original ARPAnet. They were located in the respective computer research labs of UCLA.

Internet Protocol software was soon being placed on every type of computer, and universities and research groups also began using in-house networks known as Local Area Networks or LAN's. These in-house networks then started using Internet Protocol software so one LAN could connect with other LAN's.

In 1986, one LAN branched out to form a new competing network, called NSFnet (National Science Foundation Network). NSFnet first linked together the five national supercomputer centers, then every major university, and it started to replace the slower ARPAnet (which was finally shutdown in 1990). NSFnet formed the backbone of what we call the Internet today.

Shareware

In 1982, a couple of programmers, Andrew Fluegleman and Jim Knopf had written a couple of major applications on their new IBM PCs. Not wanting to invest the time and money in trying to get these applications into stores, they decided to take advantage of the pirate distribution networks by allowing their programs to be copied.

Fluegleman called this "Freeware" and trademarked that name. Fluegleman soon lost control over it, however, when dozens of programmers distributed "improved" versions of Fluegleman's PC-Talk.

In 1984 Freeware Became Shareware, a name thought up by Bob Wallace.

The Subway

The 2750-foot (850-m) Cobble Hill Tunnel in Brooklyn, New York is claimed to be the "world's oldest subway tunnel".
It was formed in 1850 when an open cut on the Brooklyn and Jamaica Railroad in the middle of Atlantic Avenue was bricked over to form a tunnel.
This tunnel was not a true subway, as it had no stations and was used for long-distance regional rail and streetcars.

The first real underground line in the sense discussed here was the Metropolitan Railway in London, which opened in 1863, using the era's most advanced propulsive technology: steam locomotives. It was an immediate success and many extensions followed. Steam-working underground lasted until 1905 when it was replaced by electricity.

Stamps

The adhesive postage stamp and the uniform postage rate were devised in Great Britain by James Chalmers around 1834.

Chalmers' ideas were adopted by Parliament in August, 1839 and the General Post Office launched the Penny Post service the next year with two prepaid-postage pictorial envelopes: one valued at a penny and one valued at twopence. Three months later the first prepaid-postage stamp, known as the Penny Black, was issued with the profile of Queen Victoria printed on it.

FACTS FACTS FACTS

Because the United Kingdom issued the first stamps, the Universal Postal Union (U.P.U.) grants it an exemption from its rule that the identification of the issuing country must appear on a stamp in Roman script for use in international mails.

The World Wide Web

The World Wide Web was developed in 1989 by English computer scientist Timothy Berners-Lee to enable information to be shared among internationally dispersed teams of researchers at the European Laboratory for Particle Physics near Geneva, Switzerland.

The Yellow Pages

In 1886, Reuben H. Donnelly produced the first Yellow Pages directory featuring business names and phone numbers, categorized by the types of products and services provided.

EVERYDAY ITEMS

The Bar Code

The first patent for a bar code-type product (US Patent #2,612,994) was issued to inventors Joseph Woodland and Bernard Silver on October 7, 1952. The Woodland and Silver bar code can be described as a "bull's eye" symbol, made up of a series of concentric circles.

A local food chain store owner had made an inquiry to the Drexel Institute asking about research into a method of automatically reading product information during checkout. Bernard Silver joined together with fellow graduate student Norman Joseph Woodland to work on a solution.

Bar codes were first used commercially in 1966, but it was soon realized that there would have to be some sort of industry standard. By 1970, the Universal Grocery Products Identification Code or UGPIC was written by a company called Logicon Inc. UGPIC evolved into the U.P.C. symbol, or Universal Product Code, which is still used in the United States.

In June of 1974, the first U.P.C. scanner was installed at a Marsh's supermarket in Troy, Ohio.

TRIVIA TRIVIA TRIVIA

The first product to have a bar code was a packet of Wrigley's Gum.

Dandruff Shampoo

Anti-dandruff shampoo was patented by Josie Stuart in 1903.

The standard treatment has been a tar shampoo that contains salicylic acid. Other less effective products contain zinc pyrithione, selenium sulfide, or coal tar; and various generic products with the same active ingredients.

Household remedies to get rid of dandruff have been apple cider vinegar, salt or lemon juice.

Bottled Water

The origins of bottled water can be traced to the earliest civilizations. Well aware of water's health benefits, the Romans searched for and developed sources as they set about establishing their empire.

In the eighteenth century, science and medicine touted natural mineral water's beneficial effects for bathing, showering and drinking, and in the 1850s cold spa waters were bottled for the first time in France.

The legal permit to bottle Vittel Grande Source natural mineral water was granted as early as 1855. Perrier followed in 1863, and other European countries a few years later. In North America, Poland Spring water was bottled for sale in three gallon demi-johns in 1845.

In the early days, consumption of bottled natural mineral water was the privilege of the captains of industry, politicians, royalty, and the cream of society. It was bottled in glass or stoneware, with porcelain or cork stoppers.

Vittel revolutionized the market in 1968 by launching the first plastic bottle aimed at more general public consumption. In the mid-1980s, another revolution moved the market forward with PET, a new recyclable plastic material that became the packaging benchmark worldwide.

FACTS FACTS FACTS

The global bottled water market totaled
126 billion litres in 2002.

According to legend, after crossing the Pyrenees, Hannibal, the famous general of the Carthaginian army, rested his troops and elephants at Les Bouillens in France, the location of the Perrier spring.

Contact Lenses

Leonardy Da Vinci, in 1508, actually sketched out and described several forms of contact lenses, but it wasn't until 1801 that a prototype was made, by Thomas young, who developed Descartes' idea of the corneal contact lens - a quarter-inch-long, water-filled glass tube, the outer end containing a microscopic lens -- and used it to correct his own vision.

In 1887, glassblower F.E. Muller of Wiesbaden, Germany, produced the first eye covering designed to be seen through and tolerated. William Feinbloom, a New York optometrist, built on this idea by introducing plastic as the main material in the lens. In 1950, Dr. George Butterfield, an Oregon optometrist, designed a corneal lens, the inner surface of which follows the eye's shape instead of sitting flat, making the lens more comfortable. In 1971 the soft contact lens became available for commercial distribution in the United States and, in 1987, disposable soft contact lenses became available for commercial distribution.

Deodorant

The first deodorant was called "Mum" and was created in 1888 by an unknown inventor from Philadelphia. The inventor quickly trademarked his invention and marketed it through his nurse.

In the late 1940's Helen Barnett Diserens developed an underarm deodorant based on the same principle as a new invention called the 'ball point' pen. This new type of deodorant applicator was tested in the U.S. in 1952 and was marketed under the name "Ban Roll-On".

Dental Floss

Dental floss is an ancient invention. Researchers have found dental floss and toothpick grooves in the teeth of prehistoric humans.

Levi Spear Parmly (1790-1859), a New Orleans dentist, is credited as being the inventor of modern dental floss. Parmly promoted teeth flossing with a piece of silk thread in 1815.

In 1882, the Codman and Shurtleft Company of Randolph, Massachusetts, started to mass-produce unwaxed silk floss for commercial home use. The Johnson and Johnson Company of New Brunswick, New Jersey were the first to patent dental floss in 1898. Dr. Charles C. Bass developed nylon floss as a replacement for silk floss during WW II. Nylon or shredproof Teflon flosses are still believed to be the best materials for removing plaque from the teeth.

Home Pregnancy Tests

The ancient Egyptians watered bags of wheat and barley with the urine of possibly pregnant women. Germination indicated pregnancy, and based on what type of grain sprouted, they could predict the gender of the fetus.

Selmar Aschheim and Bernhard Zondek introduced testing based on the presence of hCG in 1928. In their test an infantile female mouse was injected subcutaneously with urine of the person to be tested, and some time later the mouse was sacrificed. Presence of ovulation indicated that the urine contained hCG and meant that the woman was pregnant.
An improvement arrived with the frog test that was still used in the 1950s. A female frog was injected with serum or urine of the patient. If the frog produced eggs within the next 24 hours, the test was positive. In the frog test, the animal remained alive, and could be used again.

The home pregnancy test used to be a mini-science lab with several vials containing liquids and powders that you mixed and waited and stirred and waited. Then you poured and waited.The home pregnancy tests of today still look for Human Chorionic Gonadtropin, or hCG, and the basic premise remains the same - a pregnant woman has hCG detectable in her urine.

FACTS FACTS FACTS

hCG nearly doubles about every
48 hours in early pregnancy.

Makeup

The first archaeological evidence of cosmetics usage is found in Ancient Egypt around 4000 BC. The Ancient Greeks and Romans used cosmetics containing mercury.

In Japan, geishas wore lipstick made of crushed safflower petals to paint the eyebrows and edges of the eyes as well as the lips. Sticks of bintsuke wax, a softer version of the sumo wrestlers' hair wax, were used by geishas as a makeup base.

In the 1800s, Queen Victoria publicly declared makeup impolite. It was viewed as vulgar and something that was worn by actors and prostitutes. By World War II, cosmetics had common application in the West.

The true market developers were the 1910s American trio Elizabeth Arden, Helena Rubinstein and Max Factor.

TRIVIA TRIVIA TRIVIA

The oldest and largest cosmetic firm is L'Oréal, which was founded by Eugene Shueller in 1909 as the French Harmless Hair Colouring Company.

Perfume

Perfumery, or the art of making perfumes, began in ancient Egypt but was developed and further refined by the Romans and the Arabs. Knowledge of perfumery came to Europe via the Arabs as early as the 14th century. During the Renaissance period, perfumes were used primarily by royalty and the wealthy to mask bodily odors resulting from the sanitary practices of the day.

By the 18th century, aromatic plants were being grown in the Grasse region of France to provide the growing perfume industry with raw materials. Perfumers were also known to create poisons; for instance, a French duchess was murdered when a perfume/poison was rubbed into her gloves and was, thus, slowly absorbed into her skin.

Today, France remains the centre of the European perfume design and trade.

FACTS FACTS FACTS

Timeline of Well-known Perfumes:

1921 : N°5 by Chanel (Ernest Beaux)
1925 : Shalimar by Guerlain (Jacques Guerlain)
1948 : L'Air du temps by Nina Ricci (Francis Fabron)
1977 : Opium by Yves Saint-Laurent (Jean-Louis Sieuzac)
1979 : Anaïs Anaïs by Cacharel (Roger Pellegrino)
1985 : Poison by Christian Dior (Jean Guichard)
1995 : CK One by Calvin Klein (Firmenich)

Post-It

In 1968, while attempting to design a strong adhesive,
Spencer Silver, a 3M researcher instead developed an
adhesive that was very weak.
No immediate application was apparent, until 1974 when
a colleague, Arthur Fry, conceived of using the adhesive
to create bookmarks while contemplating a hymnal in
his church choir.

Initial prototypes were available in 1977, and by 1980–1981,
after a large sampling campaign, the product was introduced
around the world.

TRIVIA TRIVIA TRIVIA

There is software that partly mimics the behaviour
of Post-it notes on your computer desktop.

The Safety Pin

One day in 1849, inventor Walter Hunt wanted to pay a fifteen-dollar debt to a friend. So he decided to invent something new.

From a piece of brass wire he made the first safety pin. He took out a patent on his invention, sold the rights to it for four hundred dollars, paid his friend back and had three hundred eighty-five dollars to spare.

Shopping Mall

A shopping mall is the modern adaptation of the historical marketplace.

The first shopping mall was the Country Club Plaza, founded by the J.C. Nichols Company and opened near Kansas City, in 1922. In the 1980s, giant megamalls were developed. The West Edmonton Mall in Alberta, Canada, opened in 1981 - with more than 800 stores and a hotel, amusement park, miniature-golf course, church, "water park" for sunbathing and surfing, a zoo and a 438-foot-long lake. Today the largest mall in the world is the South China Mall in Dongguan, China, with 1,500 stores and 7.1 million square feet.

Sunscreen

Throughout the early twentieth century, H.A. Milton Blake, a South Australian chemist, and several others attempted to create an effective sunscreen but failed.

It was not until 1944 that the first effective sunscreen was invented. World War II was in full swing at that time and many soldiers were getting serious sunburn. A pharmacist named Benjamin Greene decided to create something that would save the soldiers from the sun's harmful rays. In his wife's oven, he created a sticky, red substance which he called "red vet pet". Greene tested it on his own bald head. It didn't work nearly as well as modern sunscreens, but it was a start.

Greene then created a more user friendly sunscreen which he began selling to customers in and around Miami. He founded the Coppertone company and his sales on this new kind of sunscreen boomed.

TRIVIA TRIVIA TRIVIA

The ancient Greeks used olive oil as a type of sunscreen.

Toilets

Toilets appeared early in history. In the year 2500 BCE, the people of Harappa in India had water borne toilets in each house that were linked with drains covered with burnt clay bricks. There were also toilets in ancient Egypt and China.
In Roman civilization, toilets were sometimes part of public bath houses where men and women were together in mixed company.

The invention of the flush toilet is credited to Sir John Harington in 1596, though it took improvements for flushing toilets to become widely used.
Before and during this transitional period many people used outdoor outhouses instead, particularly in rural areas.

Toilet paper

We owe the 1857 invention of toilet paper to American Joseph Coyetty, but it wasn't until 1880 that the British Perforated Paper Company started making the first paper to be used for wiping. This paper did not come in roll form, but in boxes of small pre-cut squares. Toilet-paper in roll form became common in America around 1907.

Toothbrush

Natural bristle brushes were invented by the ancient Chinese who made toothbrushes with bristles from the necks of cold climate pigs. French dentists were the first Europeans to promote the use of toothbrushes in the seventeenth and early eighteenth centuries. William Addis of Clerkenwald, England, created the first mass-produced toothbrush. The first American to patent a toothbrush was H. N. Wadsworth and many American Companies began to mass-produce toothbrushes after 1885. In 1938, DuPont manufactured the first nylon bristle toothbrushes.

TRIVIA TRIVIA TRIVIA

Most Americans did not brush their teeth until Army soldiers brought their enforced habits of tooth brushing back home after World War II.

Toothpaste

Toothpaste was used as long ago as 500 BC in both China and India; however, modern toothpastes were not developed until the 1800s.

In 1824, a dentist named Peabody was the first person to add soap to toothpaste. In the 1850s, John Harris added chalk as an ingredient. In 1873, Colgate mass-produced the first toothpaste in a jar. In 1892, Dr. Washington Sheffield of Connecticut manufactured toothpaste into a collapsible tube. Sheffield's toothpaste was called Dr. Sheffield's Creme Dentifrice.

Toothpick

In 1872, Silas Noble and J. P. Cooley patented the first toothpick-manufacturing machine.

FASHION

Bandannas

Bandannas have been used since the beginning of time, as a means to cover the head and protect it from either heat or cold.

The bandanna comes from the Hindi bandhana, meaning "to tie" and is a type of large, usually colorful, kerchief, usually used as head gear, or around the neck by cowboys, farmers, bakers, and railroad engineers to wipe the sweat off their faces.

A kerchief, from the French "couvre-chef", or "covers the head", is a triangular or square piece of cloth tied around the head or around the neck for protective or decorative purposes. In India, a "hand kerchief" primarily refers to a napkin made of cloth, used to maintain personal hygiene.

FACTS FACTS FACTS

Certain colors of kerchiefs are associated with gangs.
A red kerchief is associated with Bloods and a blue
one is associated with Crips, for example.

The Baseball Cap

It took many years for baseball players to settle on the style of cap so familiar today.
The first baseball team, the Knickerbockers, wore straw hats. From the 1840s to the 1870s, players wore all sorts of hats - boating caps, jockey caps, even bicycling hats.

In the 1870s, a pillbox-style hat with a flat top and a short visor became popular. This was termed "Chicago style" baseball caps. It often had horizontal stripes around it that made it look a little like a layer cake.

In 1860, the Brooklyn Excelsiors wore a cap that was a forerunner of today's baseball caps. This "Brooklyn style" had evolved from a "Boston style," and it caught on about 1900. The modern baseball caps arrived in the 1940s.

FACTS FACTS FACTS

It was outfielder Ken Griffey Jr. of the Seattle Mariners who first got children to turn their baseball caps around.

The Bikini

The modern bikini was invented by engineer Louis Reard in Paris in 1946 and named after Bikini Atoll, the site of nuclear weapon tests in the Marshall Islands, on the reasoning that the burst of excitement it would cause would be like the atomic bomb.

Reard's suit was a refinement of the work of Jacques Heim who, two months earlier, had introduced the "Atome" (named for its size) and advertised it as the world's "smallest bathing suit".

It took fifteen years for the bikini to be accepted in the United States.

In 1957 Brigitte Bardot's bikini in And God Created Woman created a market for the swimwear in the U.S., and in 1960, Brian Hyland's pop song "Itsy Bitsy Teenie Weenie Yellow Polka Dot Bikini" inspired a bikini-buying spree.

FACTS FACTS FACTS

In 1951 bikinis were banned from the Miss World Contest.

The Bra

The concept of covering or restraining the breasts dates back to 6,500 years ago in Greece, but it was in 1889 the first modern bra came to existence, using the name "le bien-être (the well-being)".

In America, Mary Phelps Jacob was granted the first U.S. patent for the brassiere, in 1913. Her invention is most widely recognized as the predecessor to the modern bra. She sold the patent to the Warner Brothers Corset Company in Bridgeport, Connecticut, for $1,500. Warner eventually made an estimated $15 million off Jacob's patent.

In 1922, Ida Rosenthal, a seamstress at a small New York City dress shop, along with shop owner Enid Bissett and husband William Rosenthal, changed the look of women's fashion. The "boyish figure" then in style downplayed women's natural curves through the use of a bandeaux brassiere. Their innovation, designed to make their dresses look better on the wearer, consisted of modifying the bandeaux bra to enhance and support women's breasts. Hence, the name "Maidenform". A later innovation is the development of sized brassieres. The company they founded became the Maidenform manufacturing company, which today boasts the #1 selling bra in department stores in the United States (the Fabulous Fit bra).

TRIVIA TRIVIA TRIVIA

In 1943, Howard Hughes designed a cantilivered brassiere for Jane Russell for her appearance in the movie "The Outlaws".

Minoan women on the island of Crete 4,500 years ago wore brassieres that revealed their bare breasts.

Fingernail Polish

There are historic records of the use of fingernail polish in ancient China and Egypt, as early as 3000 BC, where color signified social class. In the beginning the Chinese found ways to use Arabic gum, egg whites, gelatin, and bees wax to create various varnishes and lacquers for the nail.
The Egyptians, too, would commonly use henna to stain their finger nails.

FACTS FACTS FACTS

Modern nail polish is, in its composition, similar to car paint.

The Flip-Flop

Flip-flops were developed out of traditional Japanese woven or wooden soled sandals in New Zealand.

The term "flip-flop" derives from the rhythmic slapping noise that the sandals make while slapping against the wearer's heels as he or she walks.

TRIVIA TRIVIA TRIVIA

In late July 2005, members of Northwestern University's national champion women's lacrosse team were criticized for wearing flip-flops to the White House to meet with President George W. Bush.

The Hooded Sweatshirt

In 1925 the word "sweatshirt" came into the vocabulary. Sweatshirts were originally for athletes to wear while warming up, before or after sports and were utilitarian gray pullovers.

Brothers Abe and Bill Feinbloom, founded the Knickerbocker Knitting Company, in 1919. They patented a flocking process to put raised letters on clothing and began manufacturing athletic wear. They first made sweatshirts but soon added a hooded sweatshirt.

The boom of wearing university names on sweats started in the 1960's. In the late 1970's, a ladies' designer named Norma Kamali started using sweatshirt material for women's fashion jackets, skirts, and pants, making athletic fabric trendy in the process.

Jeans

Jeans were first created in Genoa, Italy, in the 16th Century, and were made for the Genoese Navy because it required all-purpose trousers for its sailors. These jeans would be laundered by dragging them in large mesh nets behind the ship, and the sea water would bleach them white. The first denim came from Nîmes France, hence the name denim. The French word for these trousers was very similar to their word for Genoa; this is where we get the term 'jeans' today.

Jeans were developed in America around 1872. Levi Strauss was a dry goods merchant living in San Francisco. One of Levi's customers was Jacob Davis, a tailor who frequently purchased bolts of cloth from the Levi Strauss & Co wholesale house. After one of Jacob's customers kept purchasing cloth to reinforce torn trousers, he had the idea to use copper rivets to reinforce the points of strain, such as on the pocket corners and at the base of the button fly. Jacobs wrote to Levi suggesting that they go into business together. After Strauss accepted Davis's offer, on May 20, 1873, the two men received patent #139,121, a patent for an "Improvement in Fastening Pocket-Openings", and the blue jean was born.

The Pantyhose

The one-piece pantyhose garment appeared in the 1960s and provided a convenient alternative to stockings. The term "pantyhose" originated in the United States, referring to the combination of "panties" with sheer nylon hosiery.

Pompoms

The first cheerleaders were organized by Princeton Pep club member, Thomas Peebler. The six cheerleaders performed at a Princeton University vs University of Minnesota American football game on November 2, 1898. The head cheerleader was Johnny Campbell and all six cheerleaders were men!

Women cheerleaders did not appear until the early 1920s. The first use of pom poms can be traced back to the 1930s, all handmade from paper. Fred Gastoff invented vinyl pompoms in 1965, first used by the International Cheerleading Foundation.

Ralph Lauren

Ralph Lauren was born Ralph Lipschitz, in the Bronx, New York, to Jewish immigrants Frank and Frida Lipschitz.

From a very young age, Ralph started working after school to earn money to buy stylish, expensive suits. After college and serving in the U.S. Army he started working for Brooks Brothers as a salesman and for whom he created the label Polo. He purchased this name from them in 1967 and in 1968 opened his own tie business, Polo Fashions, after securing a $50,000 loan from a financial backer. Since then, Lauren's fashion empire has grown into a billion-dollar business.

Sneakers

The first rubber soled shoes, called "plimsolls", were developed and manufactured in the United States in the late 1800s and were made of canvas. They were invented so boaters would not have to wear dress shoes when they were on deck.

In 1892, nine small rubber manufacturing companies consolidated to form the U.S. Rubber Company. They had a new manufacturing process called "vulcanization", discovered and patented by Charles Goodyear. Vulcanization uses heat to meld rubber to cloth or other rubber components for a sturdier, more permanent bond.

The rubber footwear divisions of U.S. Rubber were manufacturing their products under 30 different brand names. The company consolidated these brands under one name. When choosing a name, the initial favorite was Peds, from the Latin meaning foot, but someone else held that trademark. By 1916, the two final alternatives were Veds or Keds, with the stronger-sounding Keds being the final choice.

Keds® were first mass-marketed as canvas-top "sneakers" in 1917. These were the first sneakers. The word "sneaker" was coined by Henry Nelson McKinney, an advertising agent for N. W. Ayer & Son, because the rubber sole made the shoe stealthy or quiet. All other shoes, with the exception of moccasins, made noise when you walked.

Sunglasses

In 1752, eyeglass designer James Ayscough introduced his new spectacles with double-hinged side pieces and with lenses made of tinted glass. These were the first sunglass like eyeglasses, but they were not made to shield the eyes from the sun; they corrected vision problems only.

In 1929, Sam Foster sold the first pair of Foster Grants Sunglasses at Woolworth's on the Atlantic City Boardwalk.

In 1929 Edwin H. Land invented a cellophane-like polarizing filter that became the critical element in polarizing sunglass lenses. It is a process that reduces light glare. Sunglasses would not become polarized, however, until 1936, when Edwin H. Land began experimenting with making lenses with his patented Polaroid filter.

FACTS FACTS FACTS

Sunglasses first became popular in the 1930s.

The T-Shirt

The American T-Shirt began during W.W. I, when American troops noticed European soldiers wearing a comfortable and lightweight cotton undershirt during the hot and humid European summer days.

These shirts became known in the USA as "T" shirts, because of their design (shaped like a "T").

By the 1920's, "T-Shirt" had become an official word in the American English language with it's inclusion in Merriam-Webster's Dictionary. By W.W. II, both the Navy and the Army had included the T-Shirt as standard issue underwear.

Initially an undergarment, John Wayne, Marlon Brando and James Dean all shocked Americans by wearing their underwear on national TV. In 1951, Marlon Brando riveted Americans in his film "A Streetcar Named Desire" when his T-Shirt was ripped off of his body revealing his naked chest. Then James Dean in "Rebel Without A Cause" made the T-Shirt a contemporary symbol of rebellious youth.

During the late sixties and seventies, Rock and Roll bands began selling T-Shirts. Professional sports caught on and soon the officially licensed T-Shirt became the hot merchandise it is today.

Tennis shoes

The tennis shoe is the only new style of shoe to be invented in the past three hundred years.

The athletic shoe was first introduced in the 1860s as the plimsoll, a lightweight canvas shoe with a rubber sole for playing lawn croquet.
In 1916, a shoe company called Keds produced a lightweight canvas and rubber shoe that remained the basic pattern of the tennis shoe for the next fifty years. In the late 1960s, the customized athletic shoe first appeared, when University of Oregon track coach Bill Bowerman (1911–1999) began experimenting with new designs for a lightweight shoe with improved traction.

"TRIVIA TRIVIA TRIVIA"

Bowerman later became one of the founders
of the Nike shoe company.

The Thong

Fashion historians trace the thongs' first public U.S. appearance to the 1939 World's Fair when New York Mayor Fiorello LaGuardia mandated that the city's nude dancers cover themselves.

The Tuxedo

There are two theories about the first tuxedo.
According to one school of thought, the tuxedo was invented by Pierre Lorillard IV of New York City. Pierre Lorillard's family were wealthy tobacco magnates who owned country property in Tuxedo Park, just outside of New York City. At a formal ball, held at the Tuxedo Club in October 1886, the young Lorillard wore a new style of formal wear for men that he designed himself. He named his tailless black jacket the tuxedo after Tuxedo Park. The tuxedo caught on and became fashionable as formal wear for men.

However, some historians believe that the tuxedo was invented by King Edward VII. Dinner jackets in midnight blue were introduced by the Duke of Windsor as an alternative to black. This is because in artificial light midnight blue looks black, whereas black often shows a greenish tinge.

MUSIC

Boy Bands

The term "Boybands" is mostly associated with the 1980s onwards, but there has been many earlier boy groups throughout the history of pop music. The Temptations, popular in the 1960s, may be considered a boy band, while The Monkees certainly were prefabricated, and Latin boy band Menudo was founded in 1977. The Jackson Five could be considered a boy band, having reached phenomenal success in the early 70's.

FACTS FACTS FACTS

Each member of a boy band will have some distinguishing feature and be portrayed as having a particular personality stereotype, such as "the baby," "the bad boy," or "the nice boy".

Girl Groups

The girl bands have a considerably longer history than boy bands.

In the late 1950s and the beginning of the 1960s they were manufactured by producers or record companies as a vehicle for the latest work by their resident songwriters, such as Phil Spector. By the mid-late 1960s, in the face of the British Invasion and with the increase in sophistication of popular music instigated by artists such as The Beatles and Bob Dylan, their popularity began to wane with only a few (e.g. The Supremes, Martha and the Vandellas) making the transition to an earthier, soulful sound and some continued success.

Fanny was the first all-female rock act to rise to real prominence in the US and Europe. In 1969, Fanny became the first all-female rock act to win the opportunity to record a full-length album for a major recording company.

The 1990s saw a return to manufactured, packaged acts marketed as clean-cut and aimed at a young audience, especially young girls. The Spice Girls were one of the more influential girl groups in the mid-1990s, with their trademark "Girl Power".

Grunge

Grunge is a hybrid of heavy metal and punk with "dirty" guitar, strong riffs, and heavy drumming. It became commercially successful in the late 1980s and early 1990s, peaking in mainstream popularity between 1991 and 1994. The first wave of grunge bands - Green River, Mudhoney, Soundgarden - were heavier than the second, which began with the more melodic Nirvana.

After Nirvana crossed over into the mainstream, grunge lost many of its independent and punk connections and became the most popular style of hard rock in the '90s.

Heavy Metal

The discussion of the history of heavy metal can be summarized in the following key artists from three main waves of bands that to a large extent came out of Britain. In the 60's came the influential rock bands like The Beatles, The Kinks, The Who and The Rolling Stones. They were followed by "early" heavy metal bands like Led Zeppelin, Black Sabbath and Deep Purple in the early and mid 1970s. Finally, in the early 80's, the New Wave of British Heavy Metal came with Iron Maiden and Judas Priest.

The origin of the term "heavy metal" is uncertain. An early use of the term was by counter-culture writer William S. Burroughs. In his 1962 novel The Soft Machine, he introduces the character "Uranian Willy, the Heavy Metal Kid". His next novel, Nova Express, published in 1964, develops this theme further, heavy metal being a metaphor for addictive drugs.

Hip Hop

Hip hop is an anti-cultural movement that began among urban African Americans, Jamaicans and Latinos in the Bronx borough of New York City during the early 1970s,

The four main aspects, or "elements", of hip hop culture are MCing (rapping), DJing, graffiti, and breakdancing.

The movement that later became known as "hip hop" is said to have begun with the work of DJ Kool Herc in the early 70s, while competing DJ Afrika Bambaataa is often credited with having invented the term "hip hop" to describe the culture.

In 1979 the first two rap records appeared: "King Tim III (Personality Jock)," recorded by the Fatback Band, and "Rapper's Delight," by Sugarhill Gang. A series of verses recited by the three members of Sugarhill Gang, "Rapper's Delight" became a national hit, reaching number 36 on the Billboard magazine popular music charts.

Mp3

MP3 stands for MPEG Audio Layer III and it is a standard for audio compression that makes any music file smaller with little or no loss of sound quality.

The German company Fraunhofer-Gesellshaft developed MP3 technology and now licenses the patent rights.
The inventors named on the MP3 patent are Bernhard Grill, Karl-Heinz Brandenburg, Thomas Sporer, Bernd Kurten, and Ernst Eberlein.

The Fraunhofer Institut was helped with their audio coding by Dieter Seitzer, a professor at the University of Erlangen.

Punk Rock

Punk rock was started as a deliberate reaction to the mass commercialism of music, in the late 60's and early 70's.

In New York in the early 70's, artists like Patti Smith, the Velvet Underground, and the Dolls of New York (changed later to New York Dolls) brought about a new style of music, rooted in a "do-it-yourself" attitude. Short, frenetic songs, and aggressive angry messages against consumerism hit the stages at venues like New York's CBGB's.
Soon bands like the Ramones and the Talking Heads would become influences for those who shared a similar distaste in what was occurring in the music industry.

Music manager Malcolm McLaren has an indelible role in the history of punk rock, managing bands such as the New York Dolls and the Sex Pistols.
With their anarchistic view of the world, spiked hair, tattered clothes, and safety pins as jewelry, the Sex Pistols became instant celebrities.
Against the backdrop of mass consumer conformity, the punk rock movement made a statement of individuality that was heard worldwide, and influenced generations of musicians.

THINK ABOUT IT

"Being a punk" isn't the same as "being punk."

Rave

Mainstream raves began in the late 1980s as a reaction to, and rebellion against, trends in popular music, nightclub culture, and commercial radio.

In an effort to maintain distance and secrecy from the mainstream club scene, warehouses, rental halls, and outside locations most often served as raves' venues.

In an effort to control and curtail rave parties, some police and governmental bodies effectively outlawed raves in some areas.

As law enforcement agencies increasingly began paying attention to raves, concealing a party's location became important to an event's success.

Rock n roll

Rock and roll emerged in America in the 1950s, though elements of rock and roll can be heard in rhythm and blues records as far back as the 1920s. The culture icon of rock´n roll music is Elvis Presley who brought the genre to an international level.

Early rock and roll combined elements of blues, boogie woogie, jazz and rhythm and blues, and is also influenced by traditional Appalachian folk music, gospel and country and western.

There is much debate as to what should be considered the first rock and roll record. Candidates include the 1951 "Rocket 88" by Jackie Brenston & His Delta Cats, or later and more widely-known hits like Chuck Berry's "Maybellene" "Johnny B. Goode" or Bo Diddley's "Bo Diddley" or Bill Haley & His Comets' "Rock Around the Clock" or, as Rolling Stone magazine pointed out, to some controversy, in 2005, "That's All Right", Elvis Presley's first single for SUN records, in Memphis.

TRIVIA TRIVIA TRIVIA

The term "Rock-n-Roll" was first used in 1951, by Alan Freed, Cleveland disc jockey, taken from the song "My Baby Rocks Me with a Steady Roll".

Rocking was a term first used by gospel singers in the American South to mean something akin to spiritual rapture.

FOOD/DRINKS

7-up

Charles Leiper Grigg invented and marketed his first soft drink called "Whistle", in 1919.

After a dispute with management, Grigg quit his job (giving away "Whistle") and started working for the Warner Jenkinson Company. There Grigg invented his second soft drink, called "Howdy".

Together with financier Edmund G. Ridgway, Grigg went on to form the Howdy Company. Charles Leiper Grigg decided to focus on lemon-lime flavors and and in October of 1929 he invented a new drink and called it 7-up.

TRIVIA TRIVIA TRIVIA

"Bib-Label Lithiated Lemon-Lime Sodas"
was the original name for 7-up.

Beer

Beer is the first alcoholic beverage known to civilization, dating back to at least the 5th millennium BC and recorded in the written history of Ancient Egypt and Mesopotamia.

By the 14th and 15th centuries, in Europe, pubs and monasteries started to brew their own beer for mass consumption.

Most beers, until relatively recent times, were what are now called ales. Lagers were discovered by accident in the 16th century after beer was stored in cool caverns for long periods.

With the invention of the steam engine in 1765, industrialization of beer became a reality, and the discovery of yeast's role in fermentation in 1857 by Louis Pasteur gave brewmasters methods to prevent the souring of beer by undesirable microorganisms.

FUN FUN FUN

The word "honeymoon" comes from an old Babylonian wedding tradition 4,000 years ago. The bride's father would supply his son-in-law with all the beer he could drink. The month following any wedding was called the "honey month", with the word "honey" meaning beer.

On January 24, 1935, the first canned beer, "Krueger Cream Ale," was sold by the Kruger Brewing Company of Richmond, VA.

The Big Mac

The Big Mac was first sold in 1968, by McDonald's, and it was inspired by a similar double decker hamburger sold by the Big Boy chain since 1936.

The sandwich was the brainchild of Jim Delligatti, one of McDonald's earliest operators. Delligatti wanted to broaden the menu, and in 1967, McDonald's agreed to let him test a large sandwich that featured two 10:1 patties. Delligatti called it the Big Mac. It became a success and was put into national distribution by late-1968.

FACTS FACTS FACTS

Don Gorske in Wisconsin, has eaten over 20,000 Big Mac hamburgers in his lifetime, winning a place in the Guinness Book of Records.
On his first trip to McDonald's in April, 1972, Gorske consumed a total of nine Big Macs. In 2003 Don Gorske ate 741 Big Macs, an average of 2.03 Big Macs per day.

The Bubble Gum

Bubble gum was invented in 1928, by a man named Walter E. Diemer. Working as an accountant for the Fleer Chewing Gum Company in Philadelphia, he was playing around with new gum recipes in his spare time.

The new gum was less sticky than regular chewing gum. It also stretched more easily. One day he carried a five-pound glop of the stuff to a grocery store; it sold out in a single afternoon.

Diemer himself taught cheeky salesmen to blow bubbles, to demonstrate exactly what made this gum different from other gums.

FUN FUN FUN

The first bubble gum was called "Dubble Bubble".

The Chewing Gum

From very early times chewing gum was thickened resin and latex from certain kinds of trees.

The American colonists learned to chew the gum-like resin that formed on spruce trees from the Indians.
Lumps of spruce gum were sold in the eastern United States during the early 1800s, making it the first commercial chewing gum.

Inventor Thomas Adams was one day introduced to chewing chicle. Adams tried to make toys, masks, and rain boots out of chicle, but every experiment failed.
One day he popped a piece of surplus stock into his mouth. Chewing away, the idea suddenly hit him to add flavoring to the chicle. Shortly after, he opened the world's first chewing gum factory.

Chips

In the summer of 1853, American Indian George Crum was employed as a chef at an elegant resort called Moon Lake Lodge in Saratoga Springs, New York. On Moon Lake Lodge's restaurant menu were French-fried potatoes, but one dinner guest found chef Crum's French fries too thick for his liking and rejected the order. Crum cut and fried a thinner batch, but these, too, met with disapproval. Exasperated, Crum decided to rile the guest by producing French fries too thin and crisp to skewer with a fork.

The plan backfired. The guest was ecstatic over the browned, paper-thin potatoes, and other diners requested Crum's potato chips, which began to appear on the menu as Saratoga Chips, a house specialty. Soon they were packaged and sold, first locally, then throughout the New England area. It was the invention of the mechanical potato peeler in the 1920s that paved the way for potato chips to soar from a small specialty item to a top-selling snack food.

In the 1920s, Herman Lay, a traveling salesman in the South, helped popularize the food from Atlanta to Tennessee. Lay peddled potato chips to Southern grocers out of the trunk of his car, building a business and a name that would become synonymous with the thin, salty snack. Lay's Potato Chips became the first successfully marketed national brand of the potatoes.

Chocolate

The Olmec Indians are believed to be the first to grow cocoa beans as a domestic crop, around 1500-400 B.C. Back then, the consumption of cocoa beans was restricted to the Mayan society's elite, in the form of an unsweetened cocoa drink made from the ground beans. During the 14th century it becomes popular among the Aztec, who call it "xocalatl" meaning warm or bitter liquid.

Cocoa first came to Europe 1544, when a delegation of Kekchi Mayan nobels visited Prince Philip of Spain, and brought gift jars of beaten cocoa. The Spanish then began to add cane sugar and flavorings to their sweet cocoa beverages.

In 1657, the first chocolate house was opened in London by a Frenchman. The shop was called the The Coffee Mill and Tobacco Roll, and chocolate was considered a beverage for the elite class. It wasn't until 1765 that chocolate was introduced to the United States when Irish chocolate-maker John Hanan imported cocoa beans from the West Indies into Dorchester, Massachusetts, to refine them with the help of American Dr. James Baker. The pair soon after built America's first chocolate mill and by 1780, the mill was making the famous Baker's ® chocolate.
In 1847, Joseph Fry & Son discovered a way to mix the chocolate, with sugar and cocoa butter, creating a paste that could be molded. The result was the first modern chocolate bar.

FACTS FACTS FACTS

In 1753, Swedish naturalist, Carolus Linnaeus was dissatisfied with the word "cocoa," so renamed it "theobroma," Greek for "food of the gods."

The Chocolate Chip Cookie

Ruth Wakefield invented Chocolate Chip Cookies. Ruth ran a tourist lodge named the Toll House Inn. One of her favorite recipes there called for the use of Baker's chocolate, but one day Ruth found herself without the needed ingredient. She substituted a semi-sweet chocolate bar cut up into bits. However, the chocolate bar did not melt completely, the small pieces only softened, creating the first chocolate chip cookie.

FACTS FACTS FACTS

Nestle Chocolate Company printed Ruth's cookie recipe on its packaging and compensated her with a lifetime supply of Nestle chocolate.

Coca Cola

Coca-Cola was invented in Columbus, Georgia, by John S. Pemberton, originally as a coca wine called Pemberton's French Wine Coca.
In 1885, Pemberton developed Coca-Cola. It was named Coca-Cola because originally, the stimulant mixed in the beverage was coca leaves from South America, and the drink was flavored using kola nuts. Coca-Cola did actually contain cocaine at one point, in its early days before the formula was changed to contain "spent" coca leaves, or those that have been through a cocaine extraction process.

Coca-Cola was initially sold as a patent medicine for five cents a glass at soda fountains, thanks to a belief that carbonated water was good for the health. The first sales were made at Jacob's Pharmacy in Atlanta, Georgia, on May 8, 1886, and for the first eight months only nine drinks were sold each day.

Asa Griggs Candler acquired a stake in Pemberton's company in 1887 and incorporated it as the Coca Cola Company in 1888. The same year, while suffering from an ongoing addiction to morphine, Pemberton sold the rights a second time to three more businessmen: J.C. Mayfield, A.O. Murphey and E.H. Bloodworth. In 1892, Candler incorporated the current, The Coca-Cola Company and began aggressively marketing the product. 50 years later it had become a national symbol and is known throughout the world.

FACTS FACTS FACTS

Coca-Cola was sold in bottles for the first time on March 12, 1894, and cans of Coke first appeared in 1955.

Coffee

Coffee was first discovered in Eastern Africa in an area we know today as Ethiopia. A popular legend refers to a goat herder by the name of Kaldi, who observed his goats acting unusually frisky after eating berries from a bush. He found that these berries gave him renewed energy.

Monks, hearing about this amazing fruit, dried the berries so that they could be transported to distant monasteries. They reconstituted these berries in water, ate the fruit, and drank the liquid to provide stimulation for a more awakened time for prayer.

Coffee berries were transported from Ethiopia to the Arabian peninsula, and were first cultivated in what today is the country of Yemen. From there, coffee traveled to Turkey where coffee beans were roasted for the first time over open fires. The roasted beans were crushed, and then boiled in water, creating a crude version of the beverage we enjoy today.

In the 1700's, coffee found its way to the Americas by means of a French infantry captain who nurtured one small plant on its long journey across the Atlantic. This one plant, transplanted to the Caribbean Island of Martinique, became the predecessor of over 19 million trees on the island within 50 years. It was from this humble beginning that the coffee plant found its way to the rest of the tropical regions of South and Central America.

TRIVIA TRIVIA TRIVIA

Coffee was declared the national drink of the then colonized United States by the Continental Congress, in protest of the excessive tax on tea levied by the British crown.

Corn Flakes

In 1894, Dr. John Harvey Kellogg was superintendent of a famous hospital and health spa in Battle Creek, Michigan, along with his brother, Will Keith Kellogg.

The hospital stressed healthful living and kept its patients on a strict diet. The brothers invented many foods that were made from grains, and one day, after cooking some wheat, the men were called away. When they finally returned, the wheat had become stale. They decided to force the tempered grain through the rollers anyway.

The brothers baked the flakes and were delighted with their new invention. They realized they had discovered a new and delicious cereal. But it wasn't until 1906 before Kellogg's Corn Flakes were made available to the general public.

FACTS FACTS FACTS

In 1909, the very first cereal premium was offered: The Funny Jungleland Moving Pictures Booklet available with the purchase of 2 packages. The offer was available for twenty-three years!

Cotton Candy

The first people to invent cotton candy were William Morrison and John Wharton, candy makers from Nashville, Tennessee. In 1897 they invented a device that heated sugar in a spinning bowl that had tiny holes in it. They received a patent for their machine in 1899.

They introduced their invention to the world at the St. Louis Worlds Fair in 1904 and sold about 68,655 boxes for a quarter a piece, which was about the price of admission to the fair itself - and very expensive for the time.

FACTS FACTS FACTS

Cotton Candy was originally called "Fairy Floss".

Doughnut

Captain Hanson Crockett Gregory is the inventor of the donut with a hole in the middle.

William Rosenberg, a food-franchising pioneer founded the Dunkin' Donuts chain. Rosenberg opened his first coffee and doughnut shop, called the Open Kettle, in Quincy, Massachusetts in 1948. The name was changed to Dunkin' Donuts in 1950, a name that sticks to the present day.

FACTS FACTS FACTS

On the 4th of June, every year, "Donut Day" is held by the Salvation Army in Chicago.

Espresso

Espresso is a recent innovation in the way to prepare coffee and obtained its origin in 1822, with the innovation of the first crude espresso machine in France. In 1933, Dr. Ernest Illy invented the first automatic espresso machine.
The Italians perfected it, and the modern-day espresso machine was created by Italian Achilles Gaggia in 1946. Gaggia invented a high pressure espresso machine by using a spring powered lever system.

FACTS FACTS FACTS

There are presently over 200,000 espresso bars in Italy.

The Hershey Bar

At the 1893 World's Columbian Exposition in Chicago, Milton Hershey, a successful caramel candy businessman, became fascinated with the art of chocolate making. He purchased some machinery and soon started the Hershey Chocolate Company.

For years, he worked at perfecting a viable recipe for making milk chocolate - a process which up to then had been kept a closely guarded secret by the Swiss. Finally, through trial and error, he hit upon the right formula of milk, sugar and cocoa that enabled him to realize his dream, the now world-famous Hershey bar.

French Fries

The word "french fries" derives from potatoes that have been "fried in the French manner". Some say that the word "french" in "french fries" refers to the verb "to french", which means "to cut in thin lengthwise strips before cooking".

The Spanish claim that the dish was invented in Spain, the first European country in which the potato appeared. The Belgians, however, are noted for claiming that french fries are Belgian in origin.

The frozen french fry was invented by the J.R. Simplot Company in the early 1950's. Prior to the legendary handshake deal between Ray Kroc of McDonald's and Jack Simplot, fries were hand cut and peeled in the back of McDonald's restaurants.

FUN FUN FUN

When the controversy over Freedom Fries first began, the French embassy claimed that the food was actually Belgian.

The first "f" in "french fries" is generally written in lower case, because it does not refer directly to the nationality.

Ice Cream

The first frozen dessert is credited to Emperor Nero of Rome. It was a mixture of snow (which he sent his slaves into the mountains to retrieve) and nectar, fruit pulp and honey.

The first ice cream parlor in America opened in New York City in 1776, and, in 1812, Dolly Madison created a sensation when she served ice cream as a dessert in the White House at the second inaugural ball.

During the stuffy Victorian period, drinking soda water was banned on Sundays. An enterprising druggist in Evanston, IN, made a legal Sunday alternative containing ice cream and syrup, but no soda. To show respect for the Sabbath, he later changed the spelling to "sundae".

FACTS FACTS FACTS

Cookies 'N Cream holds the distinction of being the fastest growing new flavor in the history of the ice cream industry.

The Ice Cream Cone

The first true edible conical shaped cone for serving ice cream was created at the St. Louis Worlds Fair by Ernest Hamwi in 1904. His waffle booth was next to an ice cream vendor who ran short of dishes. Hamwi rolled a waffle to contain ice cream and the cone was born.

Instant Coffee

Instant coffee was invented in 1901, by Japanese American chemist Satori Kato of Chicago. In 1906, English chemist George Constant Washington, invented the first mass-produced instant coffee. In 1938, Nescafe, or freeze-dried, coffee was invented.

Jell-O

In 1845, inventor Peter Cooper, obtained the first patent for a gelatin dessert. In 1895, Pearl B. Wait, a cough syrup manufacturer from Le Roy, bought the patent from Peter Cooper and turned Cooper's gelatin dessert into a prepackaged commercial product. His wife, May David Wait, renamed the dessert "Jell-O." They were unsuccessful in selling the product, however.

When Frank Woodward, a school dropout, bought the rights to Jell-O for $450, sales were slow, so Woodward offered to sell the rights to Jell-O® brand to his plant superintendent for a mere $35. Before the sale was finalized, intensive advertising paid off and sales by 1906 had reached $1 million. Woodward's Genesee Pure Food Company was renamed Jell-O Company in 1923.

The Marshmallow

Marshmallow candy dates back to ancient Egypt where it was a honey-based candy flavored and thickened with the sap of the root of the Marsh-Mallow plant.

Up until the mid 1800's, marshmallow candy was made using the sap of the Marsh-Mallow plant (althea officinalis). Marsh-Mallow grows in salt marshes and on banks near water. Gelatin replaces the sap in the modern recipes.

Today's marshmallows are a mixture of corn syrup or sugar, gelatin, gum arabic and flavoring.

M & M's

The idea for M&M'S came to Forrest Mars Sr. while on a trip to Spain, where he encountered soldiers who were eating pellets of chocolate encased in a hard sugary coating. This prevented it from melting. Inspired by this idea, Mr. Mars went back to his kitchen and invented the recipe for M&M'S® Plain Chocolate Candies.

M&M'S were first sold in 1941, and soon became a favorite of the American GIs serving in World War II. In 1954, M&M'S Peanut Chocolate Candies were introduced.

TRIVIA TRIVIA TRIVIA

In 1981, M&M'S were chosen by the first space shuttle astronauts to be included in their food supply.

Pez Candy

In 1927, Pez was invented by the Austrian inventor Eduard Haas. Haas was an anti-smoking advocate and Pez was first sold as a cigarette substitute.

The first flavor was peppermint which is also where the name comes from. Pez comes from the German word for peppermint, "Pfefferminze".

FACTS FACTS FACTS

The famous Pez dispensers with fruit flavored candy were introduced in 1952.

The Pizza

Modern pizza is attributed to baker Raffaele Esposito of Naples in the Italian region of Campania. In 1889, Raffaele Esposito who worked in the pizzeria "Pietro... e basta così", estabilished in 1780 and still in activity, baked a special pizza especially for the visit of the King Umberto I and Queen Margherita of Savoy. He named it Pizza Margherita in honor of the Queen, thereby setting the standard by which today's pizza evolved.

An Italian immigrant to the US in 1897 named Gennaro Lombardi opened a small grocery store in New York's Little Italy. An employee of his, Antonio Totonno Pero began making pizza for the store to sell. Their pizza became so popular, Lombardi opened the first US pizzeria in 1905 at 53 1/3 Spring Street, naming it simply Lombardi's.

The international breakthrough came after World War II. During WWII, troops occupying Italy where constantly on the look out for good food when they had R&R, due to the limits of Army food and rations. They discovered the pizzerias, and local bakers were at a loss to satisfy the demand from the soldiers. The American troops involved in the Italian campaign took their appreciation for the dish back home.

FACTS FACTS FACTS

The world's first true pizzeria, Antica Pizzeria Port'Alba, opened in Naples in 1830 and is still in business today at Via Port'Alba 18.

Popcorn

The oldest ears of popcorn ever found, are about 4,000 years old and were discovered in the Bat Cave of west central New Mexico in 1948 and 1950. It is actually believed that the first use of wild and early cultivated corn was popping.
Popcorn was an important food for the 16th century Aztec Indians, who also used it as decoration for ceremonial head-dresses, necklaces and ornaments on statues of their gods.

Popcorn was very popular from the 1890s until the Great Depression. During World War II, sugar was sent overseas for U.S. troops, which meant there wasn't much sugar left in the States to make candy. Thanks to this unusual situation, popcorn consumption trippled.

One of the ancient ways to pop corn was to heat sand in a fire and stir kernels of popcorn in when the sand was fully heated. Charles Cretors, founder of C. Cretors and Company in Chicago, introduced the world's first mobile popcorn machine at the World's Columbian Exposition in Chicago in 1893.

FACTS FACTS FACTS

In the development of the microwave oven, Percy Spencer of Raytheon used popcorn in many of his experiments.

Americans today consume 17 billion quarts of popped popcorn each year. The average American eats about 59 quarts a year on their own!

The Popsicle

Frank Epperson accidently invented the Popsicle when he was just eleven years old.

He mixed some soda water powder and water, which was a popular drink in those days, and left the mixture on the back porch overnight with the stirring stick still in it.
The temperature dropped and the next day Frank had a stick of frozen soda water to show his friends at school.

Eighteen years later, in 1923, Frank Epperson remembered his frozen soda water mixture and began a business producing Epsicles in seven fruit flavors. The name was later changed to the Popsicle.

The Sandwich

John Montague, the fourth Earl of Sandwich (born 1718) was the originator of the name sandwich. Montague loved to eat beef between slices of toast. Eating his "sandwich" allowed the Earl to have one hand free for card playing.

Soft Drinks

Soft drinks can trace their history back to the mineral water found in natural springs.
The first marketed soft drinks (non-carbonated) appeared in the 17th century. They were made from water and lemon juice sweetened with honey. Vendors in Paris, France would carry tanks of lemonade on their backs and dispensed cups of the soft drink to thirsty Parisians.

In 1767, the first drinkable man-made glass of carbonated water was created by Englishmen Doctor Joseph Priestley. Three years later, Swedish chemist Torbern Bergman invented a generating apparatus that made carbonated water from chalk by the use of sulfuric acid.

Carbonated beverages did not achieve great popularity in America until 1832, when John Mathews invented his apparatus for making carbonated water.

Early American pharmacies with soda fountains became a popular part of culture. The customers soon wanted to take their "health" drinks home with them and a soft drink bottling industry grew from consumer demand.

During the 1920s, automatic vending machines began to appear. The soft drink had become an American mainstay.

TRIVIA TRIVIA TRIVIA

The term "soda water" was first coined in 1798.

Tequila

Tequila was first produced in the 16th century near the location of the city of Tequila, which was not officially established until 1656. The Aztec peoples had previously made a fermented beverage made from the agave plant which they called "octli", long before the Spanish arrived in 1521. When the Spanish conquistadors ran out of their own brandy, they began to distill this agave drink to produce North America's first indigenous distilled spirit.

Some 80 years later, around 1600, Don Pedro Sánchez de Tagle, the Marquis of Altamira, began mass-producing tequila at the first factory in the territory of modern-day Jalisco.

During the 17th and 18th century, Jose Cuervo became the first man to commercialize Tequila with legal rights from the Spanish government.

FACTS FACTS FACTS

"Con gusano" means that you get a bottle with a worm from the agave plant in it. Putting the worm there deliberately began as a marketing gimmick in the 1940s.

Sushi

Sushi's origin can be traced to the 4th century BC in Southeast Asia. Over time, it spread throughout China, and later, around the 8th century AD, it was introduced into Japan.

At the beginning of the 19th century the food service industry was mostly dominated by mobile food stalls, from which nigiri-zushi originated. Edomae, which literally means "in front of Tokyo bay," was where the fresh fish and tasty seaweed for the nigiri-zushi were obtained. Then, after the Great Kanto earthquake in 1923, nigiri sushi spread throughout Japan as the skilled edomae-zushi chefs from Edo, who had lost their jobs, were diffused all over the country.

SPORT

Aerobics

The word "aerobics" was coined by Dr. Kenneth H. Cooper, a physician at the San Antonio Air Force Hospital in Texas, to denote a system of exercise he developed to help prevent coronary artery disease.
Cooper's book about the exercise system,
Aerobics, was published in 1968.

One year later, Jackie Sorenson developed aerobic dance, a series of dance routines to improve cardiovascular fitness, which we today call "aerobics".

During the next two decades, aerobic dance and exercise in various forms spread throughout the United States and into other countries. The number of aerobics participants in the US alone grew from an estimated 6 million in 1978 to 22 million in 1987.

Baseball

The origin of American baseball lies in an informal offshoot of the English sport of cricket called "rounders," played in the Colonies as early as the mid-18th century. The game was already called "base-ball" in a children's book of 1744.

It was Alexander Joy Cartwright of New York who established the modern baseball field in 1845. In Cartwright's rules of play, the game was won by the first team to score 21 "aces" (runs), in however many innings it took.

By this time, baseball had become a leisure activity for wealthy young men. But later, after Civil War soldiers who had played baseball behind the lines brought the game back to their hometowns, baseball was both watched and played by Americans of every social status.

FACTS FACTS FACTS

The Cincinnati Red Stockings became the first all-professional team in 1869.

Basketball

Basketball started with 18 men in a YMCA gymnasium in Springfield, Massachusetts in 1881. The man who created this instantly successful sport was Dr. James Naismith.

Naismith had 14 days to create an indoor game that would provide an "athletic distraction" for a rowdy class at the School for Christian Workers. His first intention was to bring outdoor games indoors, i.e., soccer and lacrosse. However, these games proved too physical and cumbersome. Naismith then recalled a childhood game that required players to use finesse and accuracy to become successful. After brainstorming this new idea, Naismith developed basketball's original 13 rules and, consequently, the game of basketball.

As basketball's popularity grew, Naismith neither sought publicity nor engaged in self-promotion. Naismith became famous for creating the game of basketball, a stroke of genius that never brought him fame or fortune during his lifetime, but enormous recognition following his passing in 1939.

For his historic invention, Naismith's name adorns the world's only Basketball Hall of Fame, a tribute that forever makes James Naismith synonymous with basketball.

The Bicycle

Leonardo da Vinci sketched a facsimile of the modern bicycle in 1490. However, as far as we know, it never left the drawing board.

Frenchman Ernest Michaux has been called "father of the bicycle," as he and his brother Pierre added cranks and pedals to the already existing models.

British engineers were next to pick up the design and improve upon it by a number of new inventions.
The British brought the bicycle to its present form, thanks mainly to James Starley of the Coventry Sewing Machine Company.

FUN FUN FUN

Bicycles were from the beginning
nick-named "hobby horses".

Bungee Jumping

The idea of bungee jumping comes from the ancient ritual "Gkol" performed in the Pentecost Island in the Pacific Archipelago of Vanuatu.

The legend says that in the village Bunlap, a man called Tamalie had a quarrel with his wife. The wife ran away and climbed a Banyan tree where she wrapped her ankles with liana vines. When Tamalie came up to her, the woman jumped from the tree and so did her husband not knowing what had his wife done. Tamalie died but the woman survived.
The men of Bunlap were very impressed by this performance and they began to practise such jumps in case they got in similar situation. This practice transformed into a ritual for rich yam harvest and also for proving manhood.

Modern bungee jumping as we know it today actually started on the 1st of April, 1979, when group of people from the Oxford University Dangerous Sport Club, impressed by a film about "vine jumpers", jumped from 245-Clifton Suspension Bridge in Bristol, England. Using nylon braided, rubber shock cord instead of vines, they performed a four man simultaneous jump.

In early 1988, A.J. Hackett and Chris Allum, opened the first commercial jump site in Ohakune, New Zealand.

TRIVIA TRIVIA TRIVIA

A.J. Hackett jumped from the Eiffel Tower in Paris, in 1987.

Car Racing

Auto racing began almost immediately after the construction of the first successful petrol-fuelled autos. In 1894, the first contest was organized by Paris magazine Le Petit Journal, a reliability test to determine best performance.

A year later the first real race was staged, from Paris, to Bordeaux. First over the line was Émile Levassor, but he was disqualified because his car was not a required four-seater.

An international competition began with the Gordon Bennett Cup in auto racing, first held in 1900.

The first auto race in the United States, over a 54.36 mile (87.48 km) course, took place in Chicago, Illinois on November 2, 1895. Frank Duryea won in 10 h and 23 min, beating three petrol-fuelled cars and two electric.

The Frisbee

The legend begins in 1871 in Bridgeport, Connecticut, where a man named William Russell Frisbie founded a pie bakery. The busines grew and by 1905, Frisbies were flying off store shelves all over New England, foreshadowing what was to become of the family name.

In 1915, the Frisbies built a new, larger bakery in Bridgeport where factory workers reportedly broke up their workday by having a game of catch with the pie tins. The news of flying pie tins spread to nearby Yale University where cries of "Frisbie!" could be heard, like the warning "Fore!" in golf, as errant throws sailed out of control.

Walter "Fred" Morrison and Warren Franscioni seized the marketing possibility of a plastic flying disk in the mid 1940s. They called their first version The Flyin' Saucer, but it didn't sell.

Fred Morrison then launched his own updated version in 1955, renaming it the Pluto Platter Flying Saucer. It was this version of the disk that caught the eye of Spud Melin and Dick Knerr at Wham-O, and the rest, as they say, is Frisbee history. Wham-O changed the spelling from Frisbie to Frisbee and went on to make it one of the most popular toys of all time, selling over 200 million of them since 1957.

Football

American football is directly descended from rugby, played in the United Kingdom. Rugby was first introduced to North America in Canada, brought by the British Army garrison in Montreal. American football evolved from this meeting.

The first inter-collegiate football game was played between Rutgers and Princeton Universities on November 6, 1869. The game was played with two teams of 25 men each.

American football in its current form grew out of a series of three games between Harvard University and McGill University of Montreal in 1874.
McGill played rugby football while Harvard played the Boston Game, but in 1876 Yale, Harvard, Princeton, and Columbia formed the Intercollegiate Football Association, which used the rugby code.

FACTS FACTS FACTS

On September 3, 1895 the first professional football game was played, in Latrobe, Pennsylvania, between the Latrobe YMCA and the Jeannette Athletic Club.
(Latrobe won the contest 12-0).

GOLF/ THE GOLFBALL

Golf originated from a game played on the coast of Scotland during the 15th century. Golfers would hit a pebble instead of a ball around the sand dunes using a stick or club.
The earliest golf balls were thin leather bags stuffed with feathers, but couldn't be hit very far.
The gutta-percha ball was invented in 1848 and could be hit a maximum distance of 225 yards. In 1899, the first rubber balls were used and when professionally hit reached distances approaching 430 yards. Golf sticks have evolved from wooden shaft clubs to today's sets of woods and irons. In the 1880s golf bags first came into use.

In the early days of golf the balls were smooth. Players noticed that as balls became old and scarred, they traveled farther. After a while players would take new balls and intentionally pit them. Eventually manufacturers caught on, supplying balls with dimples, as they appear today.

FACTS FACTS FACTS

The first powered golf car appeared around 1962, invented by Merlin L. Halvorson.

The Jetski

The invention of both major types of PWC, or "strand-ups", is usually credited to Clayton Jacobsen II of Arizona. He invented the first Jetski, or Personal Watercraft.

The first machine was the stand-up model, Kawasaki's Jet Ski® in 1973. However, staying aboard the device was a challenge.

In the late 80s the development and production of a two-person watercraft in a sit-down style made it more stable, safe, and user-friendly than their predecessors. By the early 90s, the sit-down personal watercraft skyrocketed in popularity.

TRIVIA TRIVIA TRIVIA

The Sea-Doo®, made by Bombardier, Inc. is the best-selling boat in the world.

The Mountainbike

There have been several early forms of mountain bikes. The Buffalo Soldiers was a turn-of-the-century infantry who, in 1896, customized bicycles to carry gear over rough terrain

In 1951, the Velo Cross Club Parisien (VCCP) in France developed a sport that was remarkably akin to present-day mountain biking.

John Finley Scott was probably the first mountain bike enthusiast in the United States. In 1953 he built what he called a " Woodsie Bike", using a Schwinn World diamond frame, balloon tires, flat handlebars, derailleur gears, and cantilever brakes. John was more than twenty years ahead of his time.

The history of the mountain bike is most evident in Marin County in Northern California. In the early 1970s there were a band of cyclists, The Cupertino Riders, from Cupertino California, who were modifying their bikes to help them get up and down the south bay hills. Gary Fisher is normally credited with introducing the first purpose-built mountain bike in 1979. The designs were basically road bicycle frames with a wider frame and fork to allow for a wider tire. The handlebars were also different in that they were a straight, transverse-mounted handlebar, rather than the dropped, curved handlebars that are typically installed on road racing bicycles.

The first mass-produced mountain bikes were produced by Specialized and were configured with 18 gears.

Poker

There are no direct early ancestors of poker. Instead, it derived its present day form from many different games.

Jonathan H. Green makes one of the earliest written references to poker in 1834. Green mentions rules to what he called the "cheating game," which was then being played on Mississippi riverboats. He chose to call the game poker. However, the origin of the word "poker" is well debated. There are those who also believe that "poke" probably came from "hocus-pocus", a term widely used by magicians, or from a version of an underworld slang word, "poke," a term used by pickpockets.

During the Wild West period of United States history, a saloon with a Poker table could be found in just about every town from coast to coast.

FACTS FACTS FACTS

Poker is played more than any
other card game in the world.

Rollerblades / Inlines

In the early 1700s, an unknown Dutchman decided to go ice skating in the summer. He nailed wooden spools to strips of wood and attached them to his shoes. "Skeelers" was the nickname given to the new dry-land skaters.

In 1863, American James Plimpton made skates with two parallel sets of wheels. Plimpton's design was the first dry-land skate that could maneuver in a smooth curve. This is considered to be the birth of the modern four-wheeled roller skates.

The second big skating boom occurred in the late 70's with the marriage of disco and roller-skating. Over 4,000 roller-discos were in operation and Hollywood began making roller-movies.

FACTS FACTS FACTS

Madison Square Garden in New York
became a skating rink in 1908.

The Skateboard

The skateboard was originally conceived as a means of surfing outside of water. In the late 1950s, Californian surfing enthusiasts, frustrated that the weather and waves were not always suitable for surfing, began nailing the bases of roller skates to the front and back ends of wooden planks. Unstable as they were, these boards allowed for "sidewalk surfing" along streets and down hills.

It was not long before the fad spread through the major metropolitan areas of the US. By the early 70s, bicycle manufacturers and toy companies were producing stable, unbreakable boards with more speedy and reliable urethane wheels on flexible mounts.

TRIVIA TRIVIA TRIVIA

On August 17, 1993, patent #5,236,208 was issued to Thomas Welsh for a platform steerable skateboard.

The "Ollie" was invented by Alan Ollie Gelfand. The Ollie is a skateboarding trick involving a leap into the air with the skateboard staying flush with the feet.

Skydiving

The ancient Chinese and Leonardo da Vinci are both credited with conceiving the idea of a parachute. The first jump ever using a parachute was from a building, long before airplanes were built. Fauste Veranzio, a Hungarian, jumped from the Bell Tower of Venice in 1595. He dropped over 300 feet under a parachute with a rigid frame, very similar to drawings made by da Vinci a century earlier.

In 1797 the Frenchman Andre Jacques Garnerin made the first parachute drop from an aircraft (a gas filled balloon) but it was the American Leslie Irvin who made the first ever international free-fall parachute jump near Dayton, Ohio in 1919 using his own hand operated chute, a design which revolutionized parachuting and gave birth to a new sport.

TRIVIA TRIVIA TRIVIA

The first World Parachuting Championships were held in Bled, Yugoslavia in 1951, and the 20th World Parachuting Championships were held there in 1990. Today, parachuting forms the largest internationally represented aeronautical sport within the FAI.

The Snowboard

In 1964 a young surf freak called Sherman Poppen was dreaming about surfing the magic winter landscape of the Rockies. As a consequence, he built a surfboard for the snow. His first prototype was about 1,20 m long plastic plank: two kids' skis bolted together. It was a present for his daughter Wendy that instantly became a winner in the neighborhood.

One year later, in 1965, his idea was put into production: carried out together with a bowling-ball manufacturer, the now-called "snurfer" found its way around the country through toy-stores to Christmas trees. For the unbeatable price of $15, one million snurfers were sold in the 10 years following, and Mr. Poppen soon began to establish a competition series.

But the snurfer as a mass phenomenon disappeared as quickly as he had emerged from the white surf of the Rockies.

In 1970, Dimitrije Milovich, an east coast surfer, had an idea while he was sliding around on cafeteria trays in the snow of upstate New York. He started to develop snowboards following the example of the new short surf boards.
His company "Winterstick" is considered the first snowboard company ever.

Jake Burton, a 23-year-old student at the time was completely into snurfing and kept on improving the toy. In 1977, he decided to found his own company in Vermont. The rest is history.

Soccer

The organized sport of soccer has been played on the planet for over 3000 years. A game involving kicking a ball into a small net was used by the Chinese military during the Han Dynasty – as far back as the 2nd and 3rd centuries BC. Both the Greeks and ancient Romans played a soccer-type game which resembled modern soccer - although in this early version, teams could consist of up to 27 players. Britain is the undisputed birthplace of modern soccer. It's been a popular sport of the masses there from the 8th century on. The story goes that the locals in east England played "football" with the severed head of a Danish Prince they had defeated in battle!

In medieval times, towns and villages played against rival towns and villages – with kicking, punching, biting and gouging allowed. Hundreds of people took part and games could last all day. In 1815, the famous English School, Eton College, established a set of rules which other schools began to use. These were standardized and adopted by most of England's Universities and Colleges in 1848. This version became known as "the Cambridge Rules".

The Football Association was created on 26th of October 1863 and in 1869 it included in their rules a provision which forbade any handling of the ball, establishing the foundation on which the modern game stands.

TRIVIA TRIVIA TRIVIA

Queen Elizabeth I of England, had a law passed which provided for soccer players to be " jailed for a week, and obliged to do penance in church."

Spinning

Spinning was created in the 1980s by Johnny "G" Goldberg. His athletic training program revolutionized the whole world of fitness when he invented the Johnny G Spinner cycle.

The idea of the first spinner came into Johnny's head while he was training to run a 3000 mile cross-country race (Race Across America). He decided that it was safer to bicycle indoors after a near miss in the dark. The bike he built was with an adjustable seat and handlebars that move into several different positions. As it moves, the speed makes the pedals "spin".

Surfing

Wave riding was originally developed by Hawaiian islanders before the 15th century. In the beginning it was a noble and exclusive occupation, performed by Hawaiian kings and queens.
The boards were made of solid wood, in three different styles, depending on conditions, and varied in length from 9 to 18 feet and they were so heavy they were left by the beach.

In the 1950s and 1960s the sport exploded, when cheaper, more maneuverable and lighter boards made of fiberglass and foam became available.

Duke Kahanamoku was a Hawaiian waterman and an avid surfer at Waikiki who helped popularize surfing around the world. Duke came to Sydney in 1915 and spread surfing to Australia, where he rode a board he fashioned out of local timber. Having amazed locals with this display, he then took a woman out with him to ride tandem. Thus Australia's first surfer was a woman, Miss Isabel Letham.

By this time, surfing had also spread to California but Duke's noble enthusiasm gave it a huge kick along.

Swimming/Pools

Swimming as an organized activity goes back as far as 2500 B.C. in ancient Egypt. In Rome and Greece, swimming was part of the education of elementary age boys, and thus the Romans built the first swimming pools.
The first heated swimming pool was built by Gaius Maecenas of Rome in the first century BC.

However, swimming pools did not became popular until the middle of the 19th century. By 1837, six indoor pools with diving boards were built in London, England.
After the modern Olympic Games began in 1896, and swimming races were among the original events, the popularity of swimming pools began to spread.

Waterskiing

In 1922, Ralph Samuelson of Minnesota got an idea about skiing on water. First he tried being towed behind a boat on regular wood strips, then regular snow skis. He then manufactured his own skis and attached leather to hold his feet.

One hundred feet of sash cord was used for his towrope and a blacksmith pounded out an iron ring for a towrope handle. Samuelson's older brother Ben attached the sash rope to his boat. The maximum speed they could move was 20 mph. The eighteen year old made history on July 2, 1922 on Lake Pepin in Lake City, Minnesota.

For the next 15 years, Samuelson traveled around the United States showing off his new sport. He was also the first waterski jumper. On July 8, 1925, at Lake Pepin, he greased a half-sunken diving platform with lard and jumped 60 feet off its raised end. Later that same summer, in the same lake, he became the first speed skier. He attached a 200-foot-long sash cord to a 220-horsepower World War I flying boat and zipped along behind it at an incredible 80 miles per hour.

FUN FUN FUN

The first National and World Barefoot
Championships began in 1978.

Yoga

Images found of a meditating yogi from the Indus Valley Civilization are thought to be 6 to 7 thousand years old. The earliest written accounts of yoga appear in the Rig Veda, which began to be codified between 1500 and 1200 BC. It is difficult to establish the date of yoga from this as the Rig Veda was orally transmitted for at least a millenium.

The first Yoga text dates to around the 2nd century BC by Patanjali, and prescribes adherence to "eight limbs" (the sum of which constitute "Ashtanga Yoga") to quiet one's mind and merge with the infinite.

The first full description of the principles and goals of yoga are found in the Upanisads, thought to have been composed between the eighth and fourth centuries BC.

COMPANIES

Amazon

Founded as Cadabra.com by Jeff Bezos in 1994, in the early days of the mainstream internet. Bezos realized that an online bookstore could sell many times more than an ordinary store. Bezos renamed his company "Amazon" in reference to the world's most voluminous river, the Amazon.

Amazon.com began service in July 1995 and turned its first-ever profit in the fourth quarter of 2002. In January 2004 Its profits were $35.3 million on revenues of $5.65 billion.

Recognizing the website's success in popularizing online shopping, Time Magazine named Bezos its 1999 Man of the Year.

Apple Computers

Apple Computers was founded in Los Gatos, California on April 1, 1976 by Steve Jobs, Steve Wozniak and Ronald Wayne. The first computers were hand-built in Jobs' parents' garage, and were first shown to the public at the Homebrew Computer Club. Fifty units were sold to The Byte Shop at $500 each.

In 1977 Apple released the Apple II; it was presented to the public at the first West Coast Computer Faire on April 16 and 17, 1977.

The Apple Macintosh was launched in 1984 with a now famous Super Bowl advertisement based on George Orwell's novel 1984, declaring, "On January 24, Apple Computer will introduce Macintosh. And you'll see why 1984 won't be like "1984"".

Apple almost went bankrupt in the mid-1990s but in 1998, with the introduction of the iMac computer, and the iPod in 2001, Apple is stronger than ever.

Ford

Ford Motor Company was launched from a converted wagon factory, with $28,000 cash from twelve investors. In 1908, the Ford company released the Ford Model T, and on December 1, 1913, Ford introduced the world's first moving assembly line. It reduced chassis assembly time from 12 hours to 2 hours, 40 minutes.

By the end of 1913, Ford was producing 50% of all cars in the United States, and by 1918 half of all cars in the country were Model Ts.

On January 1, 1919, Edsel Ford succeeded his father as president of the company, and on December 2, 1927, Ford unveiled the redesigned Ford Model A and retired the Model T.

FUN FUN FUN

Henry Ford is reported to have said that "any customer can have a car painted any color that he wants so long as it is black."

Google

Google began as a research project in January 1996 by Larry Page and Sergey Brin, two Ph.D. students at Stanford. They developed a search engine that would produce improved results over the basic techniques then in use. Originally the search engine used the Stanford website with the domain google.stanford.edu. The domain www.google.com was registered on September 15, 1997. They formally incorporated their company, Google Inc., on September 7, 1998 at a friend's garage in Menlo Park, California. In 2003, the company settled into a complex of buildings, known by some as "The Googleplex".

In 2000, Google began selling advertisements associated with the search keyword to produce enhanced search results for the user.

At its peak in early 2004, Google handled upwards of 84.7 percent of all search requests on the World Wide Web through its Web site and through its partnerships. "To google" has entered a number of languages first as a slang verb and now as a standard word meaning, "to perform a web search".

TRIVIA TRIVIA TRIVIA

The Google site includes humorous features such as cartoon modifications of the Google logo, known as "Google Doodles".

McDonalds

In 1937, the two brothers Dick and Mac McDonald opened a hot dog stand called the Airdome in Arcadia, California. After three years the brothers move the Airdome building to San Bernardino, California, where they opened the McDonald's restaurant on Route 66. The first McDonald's hamburger cost $0.15. The second McDonald's opened in Phoenix, Arizona, in 1953. It is the first to feature the Golden Arches design.

In 1954, entrepreneur Ray Kroc approached the McDonald brothers with a proposition to franchise McDonald's restaurants, with himself as the first franchisee. In 1961, The McDonald brothers agree to sell Kroc business rights to their operation for one million dollars each. The agreement allowed the brothers to keep their original restaurant, but in an oversight they fail to retain rights to the name McDonald's. Renamed "The Big M", it remains open until Kroc drives it out of business by opening a McDonald's just one block north. Had the brothers maintained their original agreement, which granted them 0.5 percent of the chain's annual revenues, they and their heirs would have been collecting in excess of $100 million per year today.

FACTS FACTS FACTS

The world's oldest McDonald's restaurant still in operation is in Downey, California at the corner of Lakewood and Florence Avenue

Nike

Phil Knight and his former track coach Bill Bowerman and Jeff Johnson agreed to start a business where they, at first, sold shoes out of the back of a van at track meets.
They incorporated Blue Ribbon Sports, creating BRS, Inc.
In 1962 Phil Knight, after earning his MBA at Stanford University, traveled to Japan, where he met with executives from the shoe company Onitsuka Tiger. Knight's company, Blue Ribbon Sports, became the distributor of Tiger brand footwear for the western United States as a result of this meeting.

In 1971 the relationship between BRS, Inc. and Onitsuka Tiger deteriorated, causing Knight to begin development of a new athletic footwear brand. A graphic design student at Portland State University named Carolyn Davidson was hired by Knight to design the new brand to put on the side of his company's shoes, and was paid $35 (US) for the creation of the now-famous Swoosh logo. In 1983, Ms. Davidson received a gold Swoosh ring with an embedded diamond, along with a certificate and an undisclosed amount of Nike stock, in recognition of her work.

Along with the new brand, they needed a name for their new line of footwear. Dozens of suggestions, including Knight's favorite "Dimension Six," were rejected until Jeff Johnson dreams up the name Nike, the Greek goddess of victory. In 1972, the first Nike products, adorned with the Swoosh logo, are delivered to athletes competing in Eugene, Oregon for the US Olympic Track & Field trials.

Starbucks

The first Starbucks was opened in Seattle in 1971 by Jerry Baldwin, an English teacher, Zev Siegel a History teacher, and writer Gordon Bowker. They opened its still-operating first location across from Pike Place Market. Entrepreneur Howard Schultz joined the company in 1982, and after a couple of years the founding partners sold the Starbucks chain outright to Howard Schultz.

Its first location outside of North America was opened in Tokyo, Japan, in 1996, and today Starbucks has outlets in 30 additional countries, with a total of 9,700 locations worldwide. In April 2003 Starbucks added 150 new outlets in one day, by completing the purchase of Seattle's Best Coffee and Torrefazione Italia from AFC Enterprises.

TRIVIA TRIVIA TRIVIA

The company is noted for its non-smoking policy at all its outlets, except for one single outlet in Vienna, which has a smoking room separated by double doors from the coffee shop itself.

MODERN PROBLEMS

Global Warming

The Greenhouse Effect, a.k.a. "global warming", was first discovered by Joseph Fourier in 1824, and is defined as the process by which an atmosphere warms a planet. Global warming specifically describes an increase in the average temperature of the Earth's atmosphere and oceans and is used to describe the theory that increasing temperatures are the result of a strengthening greenhouse effect caused primarily by man-made increases in carbon dioxide and other gases.

The average global temperature has risen 0.6 ± 0.2 °C since the late 19th century, and most of the warming observed over the last 50 years is attributable to human activities. Based on observational sensitivity studies, and the climate models referenced by the IPCC, temperatures may increase by 1.4 to 5.8 °C between 1990 and 2100.

This is expected to result in other climate changes such as a rise in sea level and changes in the amount and pattern of precipitation. Such changes may increase extreme weather events such as floods, droughts, heat waves, and hurricanes, change agricultural yields, or contribute to biological extinctions.

FACTS FACTS FACTS

Mars, Venus and other planets with atmospheres also
experience greenhouse effects.

The Ozone Hole

Ozone levels, over the northern hemisphere, have been dropping by about 4% per decade, but over only approximately 5% of the Earth's surface, around the north and south poles, much larger declines have been seen; these are the ozone holes.

In 1970 Prof. Paul Crutzen pointed out the possibility that nitrogen oxides from fertilizers and supersonic aircraft might deplete the ozone layer. Independent scientist James Lovelock discovered during a cruise in the South Atlantic in 1971 that almost all of the CFC compounds manufactured since their invention in 1930 were still present in the atmosphere.

The discovery of the Antarctic "ozone hole" in 1985 by Farman, Gardiner and Shanklin came as a shock to the scientific community, because the observed decline in polar ozone was far larger than anyone had anticipated. Satellite measurements showing massive depletion of ozone around the South Pole were becoming available at the same time.

TRIVIA TRIVIA TRIVIA

Crutzen, Molina, and Rowland were awarded the 1995 Nobel Prize in Chemistry for their work on stratospheric ozone.

Skin Cancer

Sir Percival Pott in 1760 first demonstrated a cause for cancer of the skin by studying chimney sweep apprentices that got sick from, Pott theorized, the chemical in coal soot.

The number of skin cancer cases has more than doubled since the early 80s.

In the '70s and '80s the fashion for sun worship was at its peak and the increase in skin cancer we're seeing today is an inheritance from that time.

FACTS FACTS FACTS

Skin cancers occur three times more commonly than breast and lung cancers together, with about 1 million cases occurring each year in the United States.

Terrorism

Historic references to the term "terrorism" first appear during French Revolution (1789 - 1799). The most severe period of the rule was the time of the Committee of Public Safety, labeled, "The Reign of Terror" (1793 - 1794) to describe rule through a systematic use of terror exemplified especially by extensive use of the guillotine.

Despite this first use of the word "terror", in the 1st century, Zealots conducted a fierce and unrelenting terror campaign against the Roman occupiers of the eastern Mediterranean. These Zealots enlisted sicarii to strike down rich Jewish collaborators and others who were friendly to the Romans.

During the 11th century, the radical Islamic sect known as the Hash-Ishiim employed systematic murder for a cause they believed to be righteous. For two centuries, they resisted efforts to suppress their religious beliefs and developed ritualized murder into a fine art taught through generations. Political aims were achieved through the power of intimidation. Similarly, the Christian warriors of the Crusades pursued political aims by means of assaults on Muslim civilian populations.

LIFESTYLE

Bikers/Hell's Angels

The Hells Angels were formed in 1948 in Fontana, California, taking their name from the movie Hell's Angels based on the Royal Flying Corps directed by Howard Hughes.

The club is estimated to have 2,000 members and prospects in 189 chapters in 22 countries around the world.

Goth

The goth movement originated in the early 80s, with the early goth bands being much punkier and livelier, and at one stage were referred to as "Positive Punk".

In the early years the dominant goth bands were UK Decay, the Banshees and Bauhaus, followed by the Sisters of Mercy, Fields of the Nephilim, and the Mission.

Of course, at first they weren't termed "goth" bands, though some of them were referred to as "gothic" in musical style as early as 1979.

Hairdos: The Mohawk

The Mohawk is traditionally thought to be a hair style worn by the Mohican and Mohawk tribes. In reality it was the Huron who first sported the hairstyle. In times of war they plucked out their hair, except for a narrow strip down the middle of the scalp, making the final product resemble a line of buffalo running along the horizon.

Besides punk fashion, the Mohawk became known with the popularity of Mr. T, or Sgt. B.A. Baracus in the television series The A-Team. Another well-known popular cultural depiction of the Mohawk came from Martin Scorcese's film Taxi Driver.

KNOW YOUR HAWKS

Many types of mohawks exist, including:
Liberty spikes, Reverse mohawks, Fans,
Tri-hawks, Bi-hawks, and Deathhawks.

Hairdos: The Mullet

The mullet became popular in the 1970s, but was known to have been worn long before then. Urban legend has it dating back to 19th Century fishermen with long hair in back to keep them warm, hence the term "mullet". The term was also referenced in the 1967 film Cool Hand Luke, starring Paul Newman and George Kennedy, in which Kennedy's character refers to Southern men with long hair as "Mulletheads."

A turning point in the history of the mullet came in an article in the Beastie Boys' magazine, Grand Royal, in 1995, which stated "There's nothing quite as bad as a bad haircut. And perhaps the worst of all is the cut we call The Mullet". This eventually led to it being universally ridiculed.

Hairdos: Shaved

Throughout most of the 20th century, head shaving was considered somewhat unusual in many Western countries and even bore some very real negative social connotations, including its linkage to skinheads and similar subcultures.
In the United States, however, the practice became popular first among African-American males in the early 1990s, and by the end of the century the look had achieved considerable social acceptability. In other parts of the world, shaving ones head is usually done for religious or cultural reasons.

FAMOUS SHAVES

Michael Jordan and Andre Agassi.

Homosexuals

The word homosexual translates literally as "of the same sex" and has been described in texts and paintings from the earliest cultures. The first known appearance of the term homosexual in print is found in an anonymously published 1869 German pamphlet written by the Hungarian Karl-Maria Kertbeny.
Up until 1973, homosexuality was still classified as a mental illness in the Diagnostic and Statistical Manual of Mental Disorders, published by the American Psychiatric Association.

As a result of this sentiment, the terms "gay" and "lesbian" are generally preferred when discussing a person with this sexual orientation.

The Soul Patch

The soul patch, or the small beard, is most readily identified as a style popular among the beatniks and jazz artists of the 50s and 60s.

MONEY

Banks

The very first banks were the religious temples of the ancient world. They were well built and were sacred, thus deterring would-be thieves. There are records of loans from the 18th Century BC in Babylon that were made by temple priests to merchants. Ancient Rome perfected the administrative aspect of banking.

Since charging interest on loans were seen as immoral by Christians, Jewish entrepreneurs, free of Christian taboos about money, established themselves in the provision of financial services increasingly demanded by the expansion of European trade and commerce.

FACTS FACTS FACTS

Sveriges Riksbank (Swedish National Bank), the central bank of Sweden, sometimes called simply the "Bank of Sweden" is the world's oldest central bank.

Credit Cards

In 1950, the Diners' Club issued the first credit card, invented by Diners' Club founder Frank McNamara and was at first for restaurant bills only. American Express followed in 1958 and then Bank of America issued the BankAmericard, now Visa, the first bank credit card, later that same year.

Money (paper notes)

The use of paper money is related to shortages of metal for coins. In the 600s there were local issues of paper currency in China and by 960 the Song Dynasty, short of copper for striking coins, issued the first generally circulating notes.

In Europe the first banknotes were issued by Stockholm's Banoo, a prodocoseor of the Bank of Sweden, in 1660.

In 1694 the Bank of England issued the first permanently circulating banknotes.

SEX

Blowjobs

Oral sex has been considered to be taboo in many
Western countries since the beginning of the Middle Ages.
In the West, before that time, the act of oral sex was a more or
less widely accepted activity in those cultures that practiced
regular and consistent bathing.

In pre-Christian ancient Rome sexual acts were generally seen
through the prism of submission and control. Under this
system, it was considered to be abhorrent for a male to be in
any way penetrated (be controlled) by another person of lower
social standing during sex.

This logic allowed a man to receive fellatio from a woman or
another man, because the man would be directing the actions
of the person of lower rank.

The Romans regarded oral sex as being far more shameful
than, for example, anal sex -known practitioners were sup-
posed to have foul breath and were often unwelcome as
guests at a dinner table. The women of Lesbos were believed
to have introduced the practice of fellatio.
The practice was taboo for public health reasons, as well.
In Rome, the genitals were considered to be unclean.
Oral sex was thought to make the mouth dirty, and (ultimately)
to present a public health risk.

Oral sex is still nominally illegal in some national and local
jurisdictions and is expressly illegal in certain others.

Condoms

The first condoms were made of woven fabrics. These were not effective, carrying both viruses as well as sperm between the woven fibers.

The earliest effective condoms were made of sheep gut. These are still available today because of their greater ability to transmit body warmth and tactile sensation, when compared to synthetic condoms, but they are not as effective in preventing pregnancy and disease.

Mass production of condoms started in the mid-19th century, shortly after the invention of the rubber vulcanization process. Until the 1930s, condoms were made from rubber; they were still quite uncomfortable and expensive (though reusable) and thus only available to a small part of the population. When latex condoms at last became available in late 1930s, it was a leap forward in effectiveness and affordability.

FACTS FACTS FACTS

One of the early condom brands
was called "Merry Widows".

The Dildo

Dildos have been used by humans for a very long time. Exactly how long is uncertain, but there is evidence of their use throughout the past 2000 years at least. It has been suggested that stone phallic batons found in the Gorge d'Enfer may have been used as Paleolithic dildos, although these artifacts are more often interpreted as spear-straighteners. A beautiful jade phallus, which may very well have been used as a dildo, and is reckoned by curators to be about 4000 years old, is currently on display in the Ancient Chinese Sex Culture Museum near Shanghai.

Early dildos were made of stone, wood, leather, wax or pottery. Rubber dildos, usually incorporating a steel spring for stiffness, became available in the 1940s. Later, PVC dildos with a softer PVC filler became popular. In the 1990s, silicone rubber dildos became more popular, a trend that has continued as the price has come down. More recently, dildos made of borosilicate glass (Pyrex) have come on the market.

During the mid 1800's women were treated for what physicians called "hysteria". The symptoms were Irritability, excessive vaginal fluids, heavy uterus and fantasies, and was treated by the physician by "massaging" his patient until orgasm was achieved. He would use an apparatus that, although phallus shaped, was referred to as a therapeutic device.

In the earlier part of the 20th century, dildos and vibrators began to make their appearance in women's magazines and catalogues. "A device for anxiety and female tension". Sold through Sears Roebuck, these toys were described as aids that every woman would love. Their uses were encouraged as a way to keep women relaxed and content.

Porn: magazines, movies

Pornography has an extensive history. Sexually suggestive and explicit artwork is as ancient as artwork of any other content; explicit photographs date to very shortly after the invention of photography; and among the earliest films are works depicting nudity and explicit sex.

Nude human beings and sexual activities are depicted in some paleolithic art. There are numerous pornographic paintings on the walls of ruined Roman buildings in Pompeii. In Pompeii you can also see phalli and testicles engraved in the sidewalks, pointing the way to the prostitution and entertainment district, to aid visitors in finding their way.

Pornographic comic books known as Tijuana bibles began appearing in the U.S. in the 1920s.

In the second half of the 20th century, pornography in the United States evolved from the so-called "men's magazines" such as Playboy and Modern Man of the 1950s. These magazines featured nude or semi-nude women, although their genitals or pubic hair were not actually displayed. By the late 1960s, however, these magazines, which by then included Penthouse, began to evolve into the more explicit displays of today.

The first explicitly pornographic film with a plot that received a general theatrical release in the U.S. is generally considered to be Mona (also known as Mona the Virgin Nymph), a 59-minute 1970 feature by Bill Osco and Howard Ziehm.

SEX

FACTS FACTS FACTS

The 1971 film The Boys in the Sand represented a number of pornographic "firsts." It was the first generally available gay pornographic movie. It was the first porn film to include onscreen credits for its cast and crew. It was the first porn film to parody the title of a mainstream movie (in this case, The Boys in the Band). And it is the only X-rated pornographic film to be reviewed by The New York Times.

Striptease

The People's Almanac credited the origin of striptease as we know it to an act in 1890s Paris in which a woman slowly removed her clothes in a vain search for a flea crawling on her body.

Striptease enjoyed a revival with the advent of burlesque theatre, with famous strippers such as Gypsy Rose Lee. In 1940, humorist H. L. Mencken coined the term "ecdysiast" as a euphemism for strippers; it derives from the Greek "ckdusis" meaning "to molt."

MEDIA

Batman

In early 1939, the success of Superman in Action Comics prompted editors at the comic book division of National Publications to request more superheroes for their titles.
In response, Bob Kane created a character called "the Bat-Man". His collaborator Bill Finger offered such suggestions as giving the character a cowl instead of a simple domino mask, wearing a cape instead of wings, wearing gloves, and removing the red sections from the original costume. Finger wrote the first Batman story and Kane provided the art. Because Kane had already submitted the proposal for a Batman character to his editors at DC Comics, Kane was the only person given official credit at the time for the creation of Batman, and is still the sole creator listed to this day.

A number of other sources have been cited as inspirations for Batman, including Zorro, Dracula, The Shadow, Sherlock Holmes, Dick Tracy, Spring Heeled Jack and even the technical drawings of Leonardo Da Vinci.

TRIVIA TRIVIA TRIVIA

Kane negotiated a contract with National, signing away any ownership in the character in exchange for a mandatory byline on all Batman comics stating "Batman created by Bob Kane", regardless of whether or not Kane had been involved with that story at all.

Cartoons

The first examples of trying to capture motion into a drawing can already be found in paleolithic cave paintings, where animals are depicted with multiple legs in superimposed positions, clearly attempting depicting a sense of motion.

The first animated cartoon (in the traditional sense, i.e. on film) was "Fantasmagorie" by the French director Émile Cohl.

One of the very first successful animated cartoons was "Gertie the Dinosaur" by Winsor McKay. It is considered the first example of true character animation.

In the 1930s to 1960s, theatrical cartoons were produced in huge numbers, and usually shown before a feature film in a movie theater. MGM, Disney and Warner Brothers were the largest studios producing these 5 to 10-minute "shorts".

Comic Books

The precursors to modern comics were the satirical works of artists like Rudolph Töpffer and Wilhelm Bush.

In 1827, Switzerland's Rudolphe Töpffer created a comic strip and continued on to publish seven graphic novels. In 1837, The Adventures of Obadiah Oldbuck was published and it is considered the earliest known comic book. In 1842, The Adventures of Obadiah Oldbuck became the first comic book published in the United States.

In 1859, German poet and artist, Wilhelm Bush published caricatures in the newspaper Fliegende Blätter. In 1865, he published a famous comic called Max und Moritz.

The 1895 Yellow Kid created by Richard Outcault has often been cited as being the first comic strip. The reason being is that Richard Outcault was the first artist to use the balloon, an outlined space on the page where what the characters spoke was written.

TRIVIA TRIVIA TRIVIA

At first newspaper comic strips were called "the funnies" and later the term comics became more popular. Early American comic books were often collections of reprints of newspaper comic strips.

Commercials

Commercial messages and election campaign displays
have been found, as far back as, in the ruins of Pompeii.
Egyptians used papyrus to create sales messages and wall
posters. Lost-and-found advertising on papyrus was common
in Greece and Rome. However, the first commercials were
simply word of mouth. As printing developed in the 15th and
16th century, advertising expanded to include handbills.
In the 17th century advertisements started to appear in weekly
newspapers in England. The first commercial ads were used
to promote books and medicines.

In 1843 the first advertising agency was established by Volney
Palmer in Philadelphia.

Donald Duck

Donald first appeared in the Silly Symphonies cartoon
The Wise Little Hen on June 9, 1934. Donald's appearance in
the cartoon, was created by animator Dick Lundy.

In the 1940s he surpassed Mickey Mouse in the
number of cartoons reaching the theaters.

His middle name, shown in a wartime cartoon, is Fauntleroy.
The original voice of Donald was Clarence "Ducky" Nash, who
was succeeded after 50 years by Disney artist Tony Anselmo.

A daily Donald Duck newspaper comic strip began on
February 7, 1938.

Magazines

The first magazines, in the 1700s, looked more like books.

The Gentleman's Magazine, first published in 1731, is considered to be the first general-interest magazine. The oldest magazine still in print is The Scots Magazine, which was first published in 1739.

FACTS FACTS FACTS

The most widely distributed magazine in the world is The Watchtower Announcing Jehovah's Kingdom (founded in 1879). Its worldwide circulation including all editions comprises 26.5 million copies.

Napster

Shawn Fanning first released the original Napster in the fall of 1999.

Fanning wanted an easier method of finding music than by searching IRC or Lycos. Shawn's uncle, John Fanning of Hull, Massachusetts, helped him incorporate the company. The final documents gave Shawn 30% control of the company, with the rest going to his uncle. It was the first of the massively popular peer-to-peer file sharing systems.

Napster specialized exclusively in music in the form of MP3 files and presented a friendly user-interface. The result was a system whose popularity generated an enormous selection of music to download.

Mickey Mouse

Mickey was created by Ub Iwerks as a replacement for Oswald the Lucky Rabbit, an earlier star created by the Disney studio. Oswald had been created by Ub Iwerks for Charles Mintz of Universal Studios. In fact, Mickey closely resembled Oswald in his early appearances. However, Disney received an unpleasant surprise when he asked Mintz for a larger budget for his popular Oswald series. In reply, Mintz offered a budget cut. Angrily, Disney refused and quit, taking Iwerks and a loyal apprentice artist, Les Clark, with him. From that point on, Disney made sure that he owned all rights to the characters produced by his company.

In order for Walt and his older brother and business partner Roy to keep their company active, new characters had to be created to star in their subsequent animated shorts. One day, during a train ride, Walt desperately wanted to come up with a money-making character to replace the one he lost, Oswald, whom he loved dearly. He had visions of a mouse in the back of his head. He wanted to name his new creation Mortimer Mouse, but his wife Lillian Marie Bounds thought the name was too pretentious, so he changed it to Mickey Mouse.

Mickey and Minnie Mouse (Mickey's flapper girlfriend) debuted in the cartoon short Plane Crazy, first released on May 15, 1928. The short was co-directed by Walt Disney and Ub Iwerks. Iwerks was also the main animator for this short, and reportedly spent six weeks working on it.
At the time of its first release, however, Plane Crazy apparently failed to impress audiences, and Walt went on to produce a second Mickey short: The Gallopin' Gaucho.

Spiderman

Spider-man only exists because a magazine was folding.
In 1962, Stan Lee had a cockeyed concept for a superhero.
He was named after a critter that a lot of people find most
comfortable smooshed on the side of a rolled-up newspaper
– Spider-man, and Marvel Comics wasn't buying it.

Fortunately, at the time Spider-man was being thrown away by
Marvel, one of their comic titles, Amazing Fantasy, was folding
up their tent, and they were casting around for something to
throw into their final issue. So, Amazing Fantasy 15 closed up
shop with the origin story of Peter Parker, your friendly
neighborhood Spider-man.

Amazing Fantasy 15 sold out, and in a little under a year,
Amazing had a re-launch.

Superman

The first Superman character created by Jerry Siegel and Joe Shuster was not a hero, but a villain. The story did not sell, forcing the two to reposition their character on the right side of the law. The revised Superman first appeared in Action Comics #1, June 1938.

Siegel and Shuster sold the rights to DC Comics for $130 and a contract to supply the publisher with material.
By 1941 the pair was being paid $75,000 each per year, still a fraction of DC's Superman profits. In 1946, when Siegel and Shuster sued for more money, DC fired them, prompting a legal battle that ended in 1948, when they accepted $200,000 and signed away any further claim to Superman or any character created from him.

Following the huge financial success of Superman: The Movie in 1978 and news reports of their pauper-like existences, Warner Communications gave Siegel and Shuster lifetime pensions of $35,000 per year and health care benefits. In addition, any media production which includes the Superman character must include the credit,
"Superman created by Jerry Siegel and Joe Shuster."

TV / FILM

Action Movies

The genre, although popular since the '50s, did not become one of the most dominant forms in Hollywood until the 1980s and 1990s.
Actors such as Arnold Schwarzenegger, Bruce Willis and Sylvester Stallone were the biggest action movie stars of the time.

Action movies usually involve a straightforward story of good guys versus bad guys, where most disputes are resolved by using physical force. The whole movie can usually be summarized in a simple sentence, and a real action movie should also spawn one or more sequels.

Several of the common action film conventions saw their birth in the release of James Bond series. One popular element is the car chase, a feature that is almost standard in action films. Bullit and The French Connection were among the earliest films to present a car chase as an action set-piece. At present, many action films culminate in a suspenseful climax centered around a Mexican standoff between two leading characters.

Action films have mainly become a mostly-American genre, requiring big budgets, although there have been a significant number of action films from Hong Kong.

Cable Television

Cable television, formerly known as Community Antenna Television or CATV, was started by John Walson and Margaret Walson in the spring of 1948.

They formed The Service Electric Company to sell, install, and repair General Electric appliances in the Mahanoy City, Pennsylvania area. However, Mahanoy City residents had problems receiving the three nearby Philadelphia network stations with local antennas because of the region's surrounding mountains. John Walson erected an antenna on a utility pole on a local mountain top and connected the mountain antenna to his appliance store via a cable to both his store and several of his customers' homes that were located along the cable path, starting the nation's first CATV system.

The Cinema

The movie theater is a development of the stage theater. The first permanent structure designed for screening of movies was Tally's Electric Theater, completed in 1902 in Los Angeles, California.

In the next thirty years, as movie revenues exploded, independent promoters and movie studios raced to build the most lavish, elaborate, attractive theatres. These forms morphed into a unique architectural genre-the movie palace- a unique and extreme architectural genre which came to an end with the deepening of the Great Depression.

TRIVIA TRIVIA TRIVIA

The movie chains were among the first industries to install air conditioning systems which gave the theatres an addition lure of comfort in the summer period.

The big movie studios owned their own movie theaters until an antitrust ruling in 1948 put a stop to it.

Friends

Friends aired its first episode on September 22, 1994. The show was produced by Bright/Kauffman/Crane Productions in association with Warner Bros. Television for NBC were it was first broadcast.

Friends is one of the most successful sitcoms in the US. By the end of the series the six main cast members were each paid $1,000,000 per episode. Advertisements during the series finale, which attracted an audience of over 52 million viewers, cost $2,000,000 for a 30-second spot in the United States.

Friends aired its last episode on May 6, 2004.

FUN FUN FUN

55 people had to be paid to come to the studio and watch the first four episodes of The Six of Us, the show's original title.

Alternate titles were Six Of One, Across The Hall, Insomnia Cafe and Friends Like Us.

Game Shows

In the 1950s game shows fell out of favor, after it was revealed that contestants on The $64,000 Question, and other shows had been given answers and were coached by the producers.

In the middle of the 1960s, Chuck Barris conceived a new genre in which the competitor's personal life became part of the show. They were the forerunners of today's reality game show. The Dating Game, The Gong Show and The Newlywed Game, actually led to some divorces.

The height of the game show era began in the early 1970s, thanks to the success of popular game shows like The Price Is Right and Match Game.

This era of game shows officially ended in the 1990s, leaving The Price Is Right as the only daytime network game show remaining on U.S. television.

James Bond

James Bond, also known as 007, is a fictional British spy introduced by writer Ian Fleming in 1953. Fleming wrote numerous novels and short stories based upon the character and, after his death in 1964, further literary adventures were written by others.

Although initially made famous through the novels, James Bond is now probably best known from the film series. Twenty official and two unofficial films have been made featuring this character. Albert R. Broccoli and Harry Saltzman produced most of the official films up until 1974 when Broccoli became the sole producer. His daughter, Barbara Broccoli, and his stepson, Michael G. Wilson, carried on the production duties beginning in 1005.

The Jerry Springer Show

The Jerry Springer Show debuted on September 30, 1991, with journalist Sally Jessy Raphael as its first guest.

It started as a politically-oriented talk show, but when low ratings led it to be picked up by a new producer it became directed towards tawdry and provocative topics, and more and more successful.

It became a "freak show" where guests seek their fifteen minutes of fame through discussion and demonstrations of deviant behavior. Its extraordinary success has led it to be broadcast in dozens of countries.

TRIVIA TRIVIA TRIVIA

In 1999, the Chicago City Council suggested that if the fist fights and chair-throwing were real, then the guests should be arrested for committing acts of violence in the city. When asked whether the fights were genuine, Springer said, "They look real to me." Ultimately, the city council chose not to pursue the matter.

The Late Show with David Letterman

The Late Show with David Letterman is an hour-long weeknight talk show broadcast by CBS from the Ed Sullivan Theater on Broadway in New York City. The show debuted on August 30, 1993 and is produced and hosted by David Letterman. The head writers are brothers Justin Stangel and Eric Stangel. Letterman was previously the host of Late Night with David Letterman on NBC from 1982 to 1993.

MTV

MTV's roots can be traced back to 1977, when Warner Amex Cable launched the TV system, Qube, in Columbus, Ohio. The Qube system offered many specialized channels, with one channel being Sight On Sound, a music channel that featured concert footage and music oriented TV programs.

The popularity of the channel prompted Warner Amex to market the channel nationally to other cable services. At midnight on August 1, 1981, the format was changed to music video (using a concept originally devised and sold to Warner Amex by Michael Nesmith, previously a member of the hit pop band The Monkees) and the name was changed to "MTV—Music Television".

In 1984 the network produced its first MTV Video Music Awards show.

FACTS FACTS FACTS

The first music video shown on MTV was "Video Killed the Radio Star" by The Buggles.

MTV coined the term VJ (video jockey).

The Oprah Winfrey Show

The Oprah Winfrey Show is the longest-running daytime television talk show in the United States, and is hosted, produced and owned by Oprah Winfrey. The show was local in the Chicago area until it debuted nationally in 1986.

FUN FUN FUN

On the 19th season premiere of her talk show, in the fall of 2004, Winfrey surprised her 276 audience members with a free, brand new Pontiac G6. Winfrey famously exclaimed, "You get a car! You get a car! You get a car! Everybody gets a car!"

Reality TV

The first reality show in the modern sense was the PBS series An American Family. The series dealt with a nuclear family going through a divorce and was broadcast in 1973.

The series that is perhaps most responsible for inspiring the recent interest in reality television is COPS, which first aired in March of 1989.

In 2000, with the emergence of Big Brother in Europe and Survivor in the USA, there came about a plethora of game-based reality TV shows.

Seinfeld

The sitcom Seinfeld aired on NBC from 1990 to 1998, and is one of the most successful programs in television history. Created by comedian Jerry Seinfeld and writer Larry David. The creators referred to their program as the "anti-sitcom".

The program almost did not make it to the air. In 1989, NBC aired a pilot titled The Seinfeld Chronicles that was deemed "weak" by focus groups. Some executives feared the show was too hip, too urban, and too Jewish to appeal to the American masses. Seinfeld returned in 1991 as a mid-season replacement and soon emerged as the most important show of NBC.

More than thirty million viewers tuned in each week to see the Seinfeld foursome.

Sex and the City

Sex and the City is a book by Candace Bushnell based on her and her friends' lifestyles. It was first published in 1997. The book, like the television series that followed it, takes its name from a column that Bushnell began writing in 1994.

It was originally broadcast on the HBO network from 1998 until 2004.

Sex and the City premiered on June 6, 1998, and the last original episode aired on February 22, 2004.

The Simpsons

The Simpsons was created by cartoonist Matt Groening and first appeared in 1987 as a series of 30-second spots produced for the Emmy Award-winning variety series The Tracey Ullman Show.

The Simpsons premiered as a half-hour comedy series January 14, 1990. The series received the 1990, 1991, 1995 and 1997 Emmy Awards for Outstanding Animated Program.

The voices behind the characters include Dan Castellaneta as Homer, Julie Kavner as Marge, Nancy Cartwright as Bart, Yeardley Smith as Lisa and series regulars Harry Shearer and Hank Azaria. Throughout its first 100 episodes, The Simpsons has attracted many celebrity guest voices to its ranks. These famous guest voices have included Elizabeth Taylor, Paul Mccartney, Michelle Pfeiffer, Johnny Carson, Bette Midler, Winona Ryder, Danny DeVito, Glenn Close, The Smashing Pumpkins and Bob Hope.

FUN FUN FUN

The characters in The Simpsons are named after the members of the creator, Matt Groening's immediate family except for Bart, which is an anagram for Brat.

Sitcoms

The situation comedy format originated on radio in the 1920s. The first situation comedy is often said to be Sam and Henry which debuted on the Chicago, Illinois clear-channel station WGN in 1926, and was partially inspired by the notion of bringing the mix of humor and continuity found in comic strips to the young medium of radio.

The first network situation comedy was Amos & Andy which debuted on CBS in 1928, and was one of the most popular sitcoms through the 1930s.

FACTS FACTS FACTS

According to the 11th edition of the Merriam-Webster Collegiate Dictionary, the term "sitcom" was coined in 1951, making I Love Lucy the first sitcom to be called a sitcom.

Talk Shows

Talk shows have been broadcast on television since the earliest days of the medium. TV news pioneer Edward R. Murrow hosted a talk show entitled Small World in the late 1950s.

The Tonight Show

The Tonight Show is NBC's long-running late-night talk show, currently hosted by Jay Leno in Burbank, CA. The hour-long show premiered September 27, 1954 in a 90-minute format hosted by Steve Allen.

NBC executive Pat Weaver is credited as Tonight's creator but Steve Allen had already created much of the structure of Tonight with his local New York late-night show.

Johnny Carson had a 30 year run as the host of The Tonight Show Starring Johnny Carson.

Now in its 51st year, The Tonight Show is the second longest-running entertainment program in U.S. television history after the soap opera Guiding Light.

TRIVIA TRIVIA TRIVIA

In the very first broadcast of The Tonight Show, Steve Allen welcomes viewers with the warning, "This show is going to last forever." He has yet to be proven wrong.

TECHNICAL STUFF

Air Bags

Allen Breed invented his first sensor and safety system in 1968. This was the world's first electromechanical automotive air bag system of its kind.

General Motors first tested air bags on the 1973 model Chevrolet, that were only sold for government use. GM later did offer an option to the public of driver side airbags in full-sized Oldsmobile's and Buick's in 1975 and 1976. Cadillac's were available with driver and passenger air bags during those same years. Air bags were offered once again as an option on the 1984 Ford Tempo. By 1988, Chrysler became the first company to offer air bag restraint systems as standard equipment.

The Answering Machine

Valdemar Poulsen, a Danish telephone engineer and inventor, best known for his Telegraphone, which he patented in 1898. It was the first practical apparatus for magnetic sound recording and reproduction. It was an ingenious apparatus for recording telephone conversations. It recorded, on a wire, the varying magnetic fields produced by a sound. The magnetized wire could then be used to play back the sound.

Mr. Willy Müller invented the world's first automatic answering machine in 1935. The first answering machine was a three-foot-tall machine popular with Orthodox Jews who were forbidden to answer the phone on the Sabbath. The Ansafone, created by inventor Dr. Kazuo Hashimoto, was the first answering machine sold in the USA, beginning in 1960.

The Air Conditioning

In 1902, only one year after Willis Haviland Carrier graduated from Cornell University with a Masters in Engineering, the first air conditioning was in operation, making one Brooklyn printing plant owner very happy.

Fluctuations in heat and humidity in his plant had caused the printing paper to keep altering slightly. The new air conditioning machine created a stable environment and four-color printing became possible. All thanks to Willis Haviland, who started on a salary of only $10.00 per week.

The "Apparatus for Treating Air" (U.S. Pat# 808897) granted in 1906, was the first of several patents awarded to Willis Haviland Carrier.

Willis and six other engineers formed the Carrier Engineering Corporation in 1915 with a starting capital of $35,000 (1995 sales topped $5 billion).

In 1928, Willis Haviland Carrier developed the first residential "Weathermaker", an air conditioner for private home use.

QUOTE QUOTE QUOTE

"I fish only for edible fish, and hunt only for edible game even in the laboratory." - Willis Haviland Carrier, on being practical.

Batteries

Alessandro Volta invented the voltaic pile and discovered the first practical method of generating electricity, in 1800. Volta's voltaic pile was the first "wet cell battery" that produced a reliable, steady current of electricity.

In 1881 Carl Gassner invented the first commercially successful dry cell battery and in 1899 Waldmar Jungner invented the first nickel-cadmium rechargeable battery.

FACTS FACTS FACTS

Thomas Alva Edison invented the alkaline storage battery in 1901.

Blinkers

Electric turn signal lights were devised as early as 1907 (U.S. Patent 912,831), but were not widely offered by major automobile manufacturers until after 1939. Alternative systems of hand signals were used earlier, and they are still common for bicycles (hand signals are also sometimes used when regular vehicle lights are malfunctioning).

The Can Opener

British merchant Peter Durand made an impact on food preservation with his 1810 patenting of the tin can. In 1813, John Hall and Bryan Dorkin opened the first commercial canning factory in England. In 1846, Henry Evans invents a machine that can manufacture tin cans at a rate of sixty per hour. An significant increase over the previous rate of only six per hour.

The first tin cans were so thick they had to be hammered open. As cans became thinner, it became possible to invent simpler can openers. In 1858, Ezra Warner of Waterbury, Connecticut patented the first can opener. The U.S. military used it during the Civil War.

The Cheese Slicer

The cheese-slicer is a Norwegian invention.
On a hot summer day in 1927, carpenter Thor Bjørklund was eating a cheese sandwich his wife had prepared for him. Thor thought the slices was too thick so he used a plane, normally used for slicing wood, to try and slice the cheese.

It worked well but it was a bit difficult to use, and you couldn't store it in the kitchen. After thinking about it he took a thin piece of steel and invented the cheese slicer, which he later patented.

The Cell Phone

The basic concept of cellular phones began in 1947, when researchers looked at crude mobile car-phones and realized they could increase the traffic capacity of mobile phones substantially. However at that time, the technology to do so was nonexistent.

Dr Martin Cooper, a former general manager for the systems division at Motorola, is considered the inventor of the first modern portable handset. Cooper made the first call on a portable cell phone in April 1973. He made the call to his rival, Joel Engel, Bell Labs head of research. Bell Laboratories introduced the idea of cellular communications in 1947 with the police car technology. However, Motorola was the first to incorporate the technology into portable device that was designed for outside of a automobile use.

The Coffee Filter

Melitta Bentz, a housewife from Dresden, Germany, invented the first coffee filter. She was looking for a way to brew the perfect cup of coffee with none of the bitterness caused by overbrewing. Melitta Bentz decided to invent a way to make a filtered coffee. She experimented with different materials, until she found that her son's blotter paper used for school worked best. She cut a round piece of blotting paper and put it in a metal cup.

On June 20th, 1908, the coffee filter and filter paper were patented. On December 15th, 1908, Melitta Bentz and her husband Hugo started the Melitta Bentz Company.

TRIVIA TRIVIA TRIVIA

The Melitta Bentz Company also patented the filter bag in 1937 and vacuum packing in 1962.

The Compact Disc (CD)

At the end of the 70s, Philips, Sony, and other companies presented prototypes of digital audio discs.

In 1979 Philips and Sony decided to join forces, setting up a joint taskforce of engineers whose mission was to design the new digital audio disc. Prominent members of the taskforce were Kees Immink and Toshitada Doi. According to Philips, the compact disc was invented collectively by a large group of people working as a team.

The compact disc reached the market in late 1982 in Asia and early the following year in other markets. This event is often seen as the "Big Bang" of the digital audio revolution.
Two years later, in 1985, the CD-ROM (read-only memory) was introduced.

TRIVIA TRIVIA TRIVIA

In 2004 the annual worldwide sales of CD-Audio, CD-ROM, and CD-R reached about 30 billion discs.

The Computer

The history of computers starts out about 2000 years ago, at the birth of the Abacus, a wooden rack holding two horizontal wires with beads strung on them. When these beads are moved around all regular arithmetic problems can be done.

Charles Babbage was the first to conceptualize and design a fully programmable computer as early as 1837, but due to a combination of the limits of the technology of the time, limited finance, and an inability to resist tinkering with his design, the device was never actually constructed in his lifetime.

A succession of steadily more powerful and flexible computing devices were constructed in the 1930s and 1940s, gradually adding the key features of modern computers, such as the use of digital electronics and more flexible programmability.

Defining one point along this road as "the first computer" is exceedingly difficult. Notable achievements include the Atanasoff Berry Computer, Konrad Zuse's Z machines; the secret British Colossus computer, and the American ENIAC - the first general purpose machine.

The team who developed ENIAC came up with a far more flexible and elegant design, the stored program architecture, which is the basis from which virtually all modern computers were derived.

A number of projects to develop computers based on the stored program architecture commenced in the late 1940s; the EDSAC BEING the first practical version. Valve-driven computer designs were replaced with transistor-based computers, in the 1960s, And by the 1970s, the adoption of integrated circuit technology enabled computers to be produced at a low enough cost to allow individuals to own a personal computer of the type familiar today.

FACTS FACTS FACTS

Originally, a "computer" was a person who performed numerical calculations under the direction of a mathematician.

Computer Games

The first primitive computer and video games were developed in the 1950s and 1960s, and Arcade games developed in the 1970s and led to the so-called "Golden Age of Arcade Games". One of the most well-known of these games is Pong.
In 1952, A.S. Douglas created the first graphical computer game - a version of Tic-Tac-Toe and in 1958 William Higinbotham created the first video game ever, a game, called "Tennis for Two".

In 1962, Steve Russell invented SpaceWar!.
Spacewar! was the first game intended for computer use.
In 1967, Ralph Baer wrote the first video game played on a television set, a game called Chase.

The 1970s also saw the release of the first home video game consoles. Pong was invented in 1972, and, also in 1972, the first commercial video game console that could be played in the home, the Odyssey was released by Magnavox and designed by Ralph Baer. The Odyssey came programmed with twelve games.

The early 1980s brought about the improvement of home consoles and the release of the Atari 2600, Intellivision and Colecovision.

The video game crash of 1983 produced a dark age in the market that was not filled until the Nintendo Entertainment System (NES) reached North America in 1985.

The Computer Mouse

Douglas Engelbart invented or contributed to several interactive devices: the computer mouse, Windows, computer video teleconferencing, hypermedia, groupware, email, the Internet and more.

In 1964, Engelbart made the first prototype computer mouse, and in 1970 he received a patent for the wooden shell with two metal wheels. It was nicknamed the mouse because the tail came out the end.

The first public appearance of the mouse was at the Augmentation Research Center, in 1968.

Douglas Engelbart was awarded the 1997 Lemelson-MIT Prize of $500,000, the world's largest single prize for invention and innovation. In 1998, he was inducted into the National Inventors Hall of Fame.

Concrete

The Assyrians and Babylonians used clay as the bonding substance. The Egyptians used lime and gypsum cement. In 1756, British engineer, John Smeaton made the first modern concrete by adding pebbles as a coarse aggregate and mixing powered brick into the cement. In 1824, English inventor, Joseph Aspdin invented the first true artificial cement by burning ground limestone and clay together, creating a stronger cement

The Convertible

In the beginning, all cars were open and few were used in the winter. When reliability had been achieved, attention turned to comfort and convenience. Drafty, leaky canvas tops gradually gave way to closed cars.
By 1925 the sale of new closed cars exceeded open ones.

Although the open car gradually lost market share,
it never lost its appeal entirely. It was seen as more dashing, adventurous, and sporty.

If one point could be identified with the emergence of the convertible it would be 1927. That year saw true convertibles introduced by Buick, Cadillac, Chrysler, duPont, LaSalle, Lincoln, Stearns, Whippet and Willys.

A breakthrough came for convertibles in 1939 when Plymouth introduced the first convertible with a power top.

Chrysler's Lee Iacocca wanted to spruce up the image of his newly rescued company and brought out the 1982 Chrysler LeBaron convertible.
It was an instant success. Iacocca was a double hero;
he had not only saved Chrysler, he had revived the glamorous convertible.

TRIVIA TRIVIA TRIVIA

The 1976 Cadillac Eldorado is called
"the last convertible in America".

Other names have also been applied to convertibles, such as Phaeton and Cabriolet, the latter being favored in Europe.

The Corkscrew

The English were the first to seal wine bottles, using cork imported from Spain or Portugal. Obviously, corkscrews were invented as an easy way of removing the cork from a bottle.

The first corkscrews were derived from a gun worme, a tool with a single or double spiral end fitting used to clean musket barrels. By the early 17th century corkscrews for removing corks were made by blacksmiths.

TRIVIA TRIVIA TRIVIA

Cork comes from the wood of the Quercus Suber or cork tree, a species of Oak native to Spain.

The Dishwasher

In 1850, Joel Houghton patented the first dishwasher, a wooden machine with a hand-turned wheel that splashed water on dishes.

In 1886, Josephine Cochran invented the first practical dishwasher. She unveiled it at the 1893, World's Fair, but only the hotels and large restaurants were buying her ideas. It was not until the 1950s, that dishwashers caught on with the general public.

The Cruise Control

Ralph Teetor invented the cruise control. Teetor, blind since the age of five, built his first car, by the age of 12.

In 1945, Ralph Teetor received his first patent on a speed cruise control device. Early names for his invention included "Controlmatic", "Touchomatic", "Pressomatic" and "Speedo-stat" and finally the familiar name of "Cruise Control".

Teetor thought of inventing cruise control after a jerky car ride, riding with his lawyer, who would constantly slow down and speed up.

FACTS FACTS FACTS

Cruise control was first offered in the 1958 Chrysler Imperial, New Yorker and Windsor car models.

Duct Tape

Adhesive tape was invented in the 1920's by Richard Drew of Minnesota Mining and Manufacturing, Co.

Duct tape was first created and manufactured in 1942 by the Johnson and Johnson Permacel Division.

The original use was to keep moisture out of the ammunition cases, during the war. Because it was waterproof, people referred to the tape as "Duck Tape."
Soon, the name changed to "Duct tape" and it became the most versatile tool in the household.

The Digital Camera

Digital camera technology is evolved from the same technology that recorded television images.
In 1951, the first video tape recorder (VTR) captured live images from television cameras by converting the information into electrical impulses (digital) and saving the information onto magnetic tape.

During the 1960s, NASA converted from using analog to digital signals with their space probes to map the surface of the moon, sending digital images back to earth.

Texas Instruments patented a film-less electronic camera in 1972, the first to do so. In August, 1981, Sony released the Sony Mavica electronic still camera, the camera which was the first commercial electronic camera. However, it was more of a video camera that took video freeze-frames.

The Elevator

The safety brake for elevators was invented before the actual elevators. In 1852 Elisha Graves Otis, invented the first safety brake and literally started the elevator industry.

Today you can still ride an Otis elevator with confidence, knowing that it represents 150 years of experience in safety.

The DVD

Anticipating a repeat of the costly format war between VHS and Betamax in the 1980s, the big multimedia companies decided to unite behind a new single standard format.

The first DVD players and discs were available in November 1996 in Japan, March 1997 in the United States, 1998 in Europe and in 1999 in Australia. The first pressed DVD was the movie Twister in 1996. The movie had the first test for 2.1 surround sound. In 1999 Independence Day was the first movie to introduce 5.1 surround sound.

The Flashlight

Conrad Hubert came to the United States from Russia in 1890, flat broke, and whatever he tried, he never made much money.

Hubert had a friend named Joshua Lionel Cowen who was very interested in electricity. Joshua had invented a flower pot with a battery in it. Electricity from the battery made the flower "light up" when a button was pressed.

Hubert took the battery, the bulb and the paper tube from the pot and remade it into what he called "an electric hand torch." Hubert sold his invention at first as a novelty, but the usefulness of the flashlight soon became apparent. When he died in 1928 it must have seemed to Hubert a long time ago that he was poor. He was worth $8,000,000.

The Flatscreen TV

The Plasma display panel was invented at the University of
Illinois by Donald L. Bitzer and H. Gene Slottow in 1964 for
the PLATO Computer System.

Starting with his PhD dissertation in 1975, Larry Weber of the
University of Illinois sought to create a color plasma display,
finally achieving that goal in 1995.

Fujitsu General began selling 3-color plasma displays
to the high-end niche market in 1993.

Four Wheel Drive

The first 4WD vehicle was designed by Ferdinand Porsche for
the Austrian truck manufacturer Jacob Lohner in 1900. This
first vehicle had electric hub motors on each wheel - the
engine powered a generator for power supply. Porsche
was 25 years old when he designed it.

The world's first automaker, Daimler Benz has a solid place in
4WD history as well. Mercedes started building 4WD vehicles
1903 - some of them already with all wheel steering.

The first US four wheel drive vehicle, was built 1911 by the Four
Wheel Drive auto company (FWD) . The company was formed
by Zachow and Besserdich, and they supplied 4x4 trucks to
both the British and US armies during World War One.

The Ice Cube Tray

In 1914, Frederick Wolf Jr. invented a refrigeration device. Accompanying this device was the world's first recorded ice cube tray.

The first tray to be sold commercially was patented in 1932, being manufactured by the General Appliances Mfg. Company.

The Laptop

The first commercially available portable computer was the Osborne 1 in 1981. It was the size of a portable sewing machine and couldn't be run on batteries, it had to be plugged in.

However, the first true laptop was the GRiD Compass 1101, designed by William Moggridge in 1979, and released in 1982. Enclosed in a magnesium case, it introduced the now familiar clamshell design, in which the flat display folded shut against the keyboard. The computer could be run from batteries, and was equipped with a 320x200-pixel plasma display and 384-kilobyte bubble memory. It was not IBM-compatible, and its high price (US$ 10,000) meant that it was limited to specialized applications.

The Lava Lamp

After seeing a lamp in a pub in England, Edward Craven Walker got the idea for the original lamp design. He spent the next 15 years perfecting the The Astro Lamp, later called the Lava Lamp, before it was launched in 1963.

The Lie Detector

An early lie detector was invented by James Mackenzie in 1902. However, it didn't work very well. In 1921, John Larson, a University of California medical student, invented the modern lie detector (polygraph).

The theory is that when a person lies, the lying causes a certain amount of stress that produces changes in several involuntary physiological reactions.
Used in police interrogation and investigation since 1924, the lie detector is still controversial among psychologists, and is not always judicially acceptable.

FACTS FACTS FACTS

The name "polygraph" comes from the fact that the machine records several different body responses simultaneously as the individual is questioned.

Loud Speakers

German, Ernst Siemens patented the first loudspeaker on Dec. 14, 1877. Englishmen, Sir Oliver Lodge received the second patent for a loudspeaker on April 27, 1898. And this all before music was electrified.

In 1924, two General Electric researchers, Chester W. Rice and Edward Washburn Kellogg patented the modern loudspeaker, which become the prominent design for all loudspeakers. The Rice and Kellogg loudspeakers were sold to consumers under the name of "Radiola" loudspeakers beginning in 1926, and were superior to anything previously invented.

The Microwave

The idea of using microwave energy to cook food was accidentally discovered by Percy LeBaron Spencer of the Raytheon Company when he found that radar waves had melted a candy bar in his pocket. Experiments showed that microwave heating could raise the internal temperature of many foods far more rapidly than a conventional oven.

Neon Light

The concept behind neon signs was first conceived in 1675, when the French astronomer Jean Picard observed a faint glow in a mercury barometer tube.

The French engineer, chemist, and inventor Georges Claude, was the first to apply an electrical discharge to a sealed tube of neon gas, in 1902, to create a lamp.
Georges Claude displayed the first neon lamp to the public on December 11, 1910, in Paris.

In 1923, Georges Claude and his French company Claude Neon, introduced neon gas signs to the United States, by selling two to a Packard car dealership in Los Angeles. Earle C. Anthony purchased two signs reading "Packard" for $24,000. Neon lighting quickly became a popular fixture in outdoor advertising. Visible even in daylight, people would stop and stare at the first neon signs dubbed "liquid fire."

FACTS FACTS FACTS

The word neon comes from the Greek
"neos," meaning "the new gas."

Nuclear Power

The Italian-American physicist Enrico Fermi is known for achieving the first controlled nuclear reaction.

He created the first controlled nuclear fission chain reaction in December 1942 at the University of Chicago and worked for the rest of World War II, at Los Alamos, New Mexico, on the atomic bomb.

In 1938 Enrico Fermi was awarded the Nobel Prize in physics.

The Parking Meter

Carlton Cole Magee invented the first parking meter in 1932 in response to the growing problem of parking congestion. He patented it in 1935 and started the Magee-Hale Park-O-Meter Company to manufacturer his parking meters.

The first one was installed in 1935 in Oklahoma City.
The meters were sometimes met with resistance from citizen groups; vigilantes from Alabama and Texas attempted to destroy the meters.

Nintendo

1975 - In cooperation with Mitsubishi Electric, Nintendo developes the Nintendo video game system.

1981 - Nintendo developed and began distribution of the coin-operated video game "Donkey Kong." This video game quickly became the hottest selling individual coin-operated machine in the industry.

1985 - Nintendo starts to sell the U.S. version of Family Computer Nintendo Entertainment System (NES) in America. The system included the games Duck Hunt and Super Mario Bros. Mario and Luigi became as big a hit as the NES.

1987 - The Legend of Zelda became the first new generation home video game to exceed sales of one million units.

1991 - Nintendo introduced the 16-bit Super Nintendo Entertainment System (SNES) along with Super Mario World and released it in the U.S.

1996 - Nintendo 64 launched in Japan on June 23. Thousands lined up to be the first to experience the world's first true 64-bit home video game system. More than 500,000 systems were sold the first day.

FACTS FACTS FACTS

Nintendo has sold more than one billion video games worldwide, 40 percent of American households own a Nintendo game system.

The Refrigerator

Before mechanical refrigeration systems were introduced, people cooled their food in cellars packed with snow and ice.

The first known artificial refrigeration was demonstrated by William Cullen at the University of Glasgow in 1748. However, he did not use his discovery for any practical purpose. In 1805, an American inventor, Oliver Evans, designed the first refrigeration machine. The first practical refrigerating machine was built by Jacob Perkins in 1834.

An American physician, John Gorrie, built a refrigerator based on Oliver Evans' design in 1844 to make ice to cool the air for his yellow fever patients. German engineer Carl von Linden patented not a refrigerator but the process of liquifying gas in 1876 that is part of basic refrigeration technology.

FACTS FACTS FACTS

Several fatal accidents occurred in the 1920s when methyl chloride leaked out of refrigerators.

The Remote Control

The first TV remote control was developed in 1950 and was called "Lazy Bones". It wasn't an actual remote, it used a cable that ran from the TV set to the control, which people kept tripping over.

In 1955, Eugene Polley invented the "Flashmatic," the industry's first wireless TV remote.

Rockets

For centuries, rockets have provided ceremonial and warfare uses starting with the ancient Chinese, who were the first to create rockets. The rocket made its debut as a fire arrow used by the Chin Tartars in 1232 AD for fighting off a Mongol assault. In the 1600's, Joanes de Fontana of Italy designed a surface-running rocket-powered torpedo for setting enemy ships on fire. Claude Ruggieri, an Italian living in Paris, apparently rocketed small animals into the sky as early as 1806.

By the end of the 19th century, the possibilities of space travel were being considered. Not until the 20th century did a clear understanding of the principles of rockets emerge, and only then did the technology of large rockets begin to evolve.

Silicon

Silicon was first identified by Antoine Lavoisier in 1787. Since it is an important element in semiconductor and high-tech devices, the high-tech region of Silicon Valley, California is named after this element.

The Skyscraper

The invention of the skyscraper lies with George A. Fuller. Fuller worked on solving the problems of the "load bearing capacities" of tall buildings. He built the Tacoma Building in 1889, the first structure ever built where the outside walls did not carry the weight of the building.

The Flatiron Building was one of New York City's first skyscrapers, built in 1902 by Fuller's building company. The world's tallest building when it opened in 1913, is architect Cass Gilbert's 793-foot Woolworth Building. Today, the distinction of the World's Tallest Building goes to the Taipei 101 building, built in 2003 and standing 1671 ft high.

FACTS FACTS FACTS

The term "skyscraper" was first used during the 1880s,
shortly after the first 10 to 20 story buildings
were built in the United States.

The Slot Machine

The first mechanical slot machine was the Liberty Bell, invented in 1895 by Charles Fey, a San Francisco car mechanic. Three bells in a row produced the biggest payoff, a grand total of fifty cents or ten nickels. The original Liberty Bell slot machine can be found at the Liberty Belle Saloon & Restaurant on 4250 S. Virginia, Reno Nevada.

TRIVIA TRIVIA TRIVIA

A "fruit machine" is the British term for a
slot machine, or "one-armed bandit."

Spinners

Spinners are wheel covers which spin independently
of the wheel itself when the brakes are applied.
They were popularized by the 2003 Three 6 Mafia single
"Ridin' Spinners".

The Stair master

Arthur Jones (born in Arkansas) is the founder of Nautilus Sports Medical Industries and inventor of the Nautilus exercise machines, including the Nautilus Stair Master.
The 1977 film Pumping Iron is cited as generating a fitness revolution of sorts which resulted in gyms full of Nautilus equipment and other similar strength training machines.

TRIVIA TRIVIA TRIVIA

Jones has been named on Forbes Fortune list of the 400 richest people. His company, Nautilus Inc., posted sales of $524 million in 2004. He is also the creator of the "Jumbolair" estate, originally conceived as a haven of 350 acres for orphaned African elephants and other wildlife. Much of Jumbolair is now owned by John Travolta.

The SUV

The birth of the SUV began as the "depot hack." The depot hack was a vehicle that transported people and luggage from the train stations. They were widely known as a carryalls or suburbans. The late 1940s brought us Willy's Jeep Wagon. In an early advertisement it was called a "utility vehicle" for the family. The 70's brought us the Chrysler mini-van. It was fuel efficient, front wheel drive and could carry a whole family. SUVs were immensely popular in the late 1990s and early 2000s, but now, in the mid 2000s, their popularity has waned considerably.

FACTS FACTS FACTS

The longest running SUV model is the Suburban.

Teflon

PTFE or polytetrafluoroethylene was discovered on April 6, 1938 by Dr. Roy Plunkett at the DuPont research laboratories in New Jersey. Plunkett and his associates discovered that a Freon sample they were working on had turned spontaneously into a white, waxy solid to form polytetrafluoroethylene or PTFE.

PTFE was first marketed under the DuPont Teflon ® trademark in 1945. The molecular weight of Teflon can exceed 30,000,000, making it one of the largest molecules known. The surface is so slippery, virtually nothing sticks to it or is absorbed by it.

The Waterbed

Dr. William Hooper of Portsmouth, England, patented a waterbed in 1883. He devised it to relieve bed sore pains in his patients. However, his invention was a failure, unable to contain the water.

The modern waterbed was created by Charles Hall in 1968, while he was a design student at San Francisco State University in California. Hall originally wanted to make an innovative chair. His first prototype was a vinyl bag with 300 pounds (136 kg) of cornstarch, but the result was uncomfortable. He next attempted to fill it with Jell-O, but this too was a failure. Ultimately, he abandoned working on a chair, and settled on perfecting a bed. He succeeded. His timing could not have been more perfect. The Sexual Revolution was under way, and Hall's waterbed became enormously popular, making it one of the most notable icons of the 1970s.

The TV

1900 - The word "Television" was first used.
1928 - 1934 - First Mechanical TV Sets sold to the public.
1941 - Electronic Black & White Television begins
broadcasting in United States.
1951 - First Mechanical Color Television Set Placed on Market
(CBS-Columbia) at $499.95.
1954 - First All-Electronic Color Television Set is RCA
CT-100, selling at $1,000.
1987 - Japanese demonstrate ANALOG high-definition
TV system.

TRIVIA TRIVIA TRIVIA

Before WW-II, there were less than 7,000 TV sets in USA.

Traffic signals

In 1923, after witnessing a collision between an automobile
and a horse-drawn carriage, Garrett Morgan invented and
acquired a U.S. patent for an inexpensive-to-produce traffic
signal. The Morgan traffic signal was a T-shaped pole unit that
featured three positions: Stop, Go and an all-directional stop
position. This "third position" halted traffic in all directions to
allow pedestrians to cross streets more safely.

Garrett Morgan's hand-cranked semaphore traffic signals
were in use throughout North America until all manual traf-
fic signals were replaced by the automatic red, yellow, and
green-light signals currently used around the world.

FUN AND GAMES

The Barbie

The Barbie doll was invented in 1959 by Ruth Handler, co-founder of Mattel, and named after her own daughter who was called Barbara. Barbie was introduced to the world at the American Toy Fair in New York City as a teenage fashion doll.

The Ken doll was named after Ruth's son.

FACTS FACTS FACTS

If Barbie was a real person her measurements would be an impossible 36-18-38.

The Crossword Puzzle

British born journalist Arthur Wynne invented the crossword puzzle in 1913. Arthur Wynne wrote the first crossword puzzle for an American newspaper called the New York World. The first puzzle, called a word-cross, was published on December 21, 1913 and was diamond shaped. The name later switched to cross-word and then crossword.

Wynne based his crossword puzzle on a similar much older game called Magic Squares or word square.

TRIVIA TRIVIA TRIVIA

In 1997, the first computer software program that creates crossword puzzles was patented.

Lego

Ole Kirk Christiansen, a poor carpenter from Billund, Denmark started creating wooden toys in 1932, but it wasn't until 1949 that the famous plastic Lego brick was created.

The company name Lego was coined by Christiansen from the Danish phrase "leg godt", meaning "play well".

In 1947, Ole Kirk and his son Godtfred obtained samples of interlocking plastic bricks produced by the company Kiddicraft. These "Kiddicraft Self-Locking Building Bricks" were designed and patented in the UK by Mr. Hilary Harry Fisher Page, a child psychologist. A few years later, in 1949, Lego began producing similar bricks, calling them "Automatic Binding Bricks."

The use of plastic for toy manufacture was not highly regarded by retailers and consumers of the time. Many of the Lego Group's shipments were returned, following poor sales; it was thought that plastic toys could never replace wooden ones.

By 1954, Christiansen's son, Godtfred, saw the immense potential in Lego bricks to become a system for creative play, but it wasn't until 1958 that the modern-day brick design was developed.

Over the years many more Lego sets, series, and pieces were created, with many innovative improvements and additions, culminating into the colourful versatile building toys that we know today.

Monopoly

Monopoly dates back to 1904, when Lizzie Magie, patented a game called "The Landlord's Game" with the object of demonstrating how rents enrich property owners and impoverish tenants. She thought these ideas might be easier to demonstrate if they were put into the form of a game.

Monopoly was first sold by Parker Brothers on November 5, 1935. Today, an estimated 500 million players from around the globe have been mesmerized by the Monopoly game since its creation.

FACTS FACTS FACTS

Monopoly is the world's most popular board game.

Mr. Potato Head

George Lerner of New York City invented and patented Mr. Potato Head in 1952. It was based on an earlier toy called "make a face" that used a real potato.

Lerner sold Mr. Potato Head to the Hassenfeld Brothers of Rhode Island, who owned the toy company Hasbro Inc. Hasbro sold the first Mr. Potato Head with a styrofoam head as a base for the facial plug-ins. In 1953, Mrs. Potato Head was added, and soon after Brother Spud and Sister Yam completed the Potato Head family.

Although originally produced as separate plastic parts to be stuck into a real potato or other vegetable, a plastic body was added to the kit in 1964.

TRIVIA TRIVIA TRIVIA

Mr. Potato Head was the first toy to be advertised on television.

In 1985, Mr. Potato Head received four write-in votes in the mayoral election in Boise, Idaho.

The Pin-ball machine/Pinball

History records the existence of table-based games back to the 15th Century.

In France, during the reign of King Louis XIV, someone took a billiard table and narrowed it, placing the pins at one end of the table while making the player shoot balls with a stick or cue from the other end.
The table game was dubbed Bagatelle.

In 1869, a British inventor named Montegue Redgrave settled in America and manufactured bagatelle tables out of his factory in Cincinnati, Ohio, USA. In 1871 Redgrave was granted US Patent #115,357 for his "Improvements in Bagatelle", which replaced the cue at the player's end of the table with a coiled spring and a plunger. The player shot balls up the inclined playfield using this plunger, a device that remains in pinball to this day.

Early pinball machines appeared in the early 1930s. They were countertop machines without legs. "Bally Hoo" was the first coin-operated pinball game, introduced in 1931 and invented by Raymond Maloney who founded the Bally Corporation.

The tilt mechanism was one of the first addition to pinball games, invented in 1934 as a direct answer to the problem of players lifting and shaking the games.

The pinball bumper was invented in 1937.

The flipper was invented in 1947, introduced in a pinball game called "Humpty Dumpty" made by D. Gottlieb & Company.

TRIVIA TRIVIA TRIVIA

The term "pinball", as a description of the game,
was first used in 1936.

The Rollercoaster

In Russia, during the reign of Catherine the Great, there were large ice slides that people enjoyed sledding down.
French soldiers grew fond of the ice slides While stationed in Russia and brought the idea of the roller coaster back with them to France.

The first two roller coasters that operated on a continuous circuit were built in 1817 in France. These first coasters flew down the hill at an excess of 30 mph, after the coaster reached the bottom of the hill, attendants had to push the car up again to repeat the cycle.
In 1872, a mining company in the mountains of Pennsylvania started what they called the Mauch Chunk Railroad. The ride was an out-dated coal train that was pushed up the hill by a coal engine and then flew back down to the base of the hill. This coaster still holds the record for the tallest and longest roller coaster ever built. It stood 1,269 feet high with a track istance of 18 miles, and it cost a dollar for this one hour and twenty minute ride.
Born on March 8, 1848, the inventor and millionaire La Marcus Thompson traveled around the United States and happened upon the Mauch Chunk Railroad The roller coaster interested him, and he decided that he was going to build the first wood en coaster in the United States, and soon after Thompson's Switch back Railroad was built at Coney Island in Brooklyn, New York. The ride topped out at 50 feet and was an immediate success.

FACTS FACTS FACTS

The Mauch Chunk Railroad became the United State's second most visited attraction, right behind Niagara Falls.

Scrabble

Alfred Butts is the inventor of Scrabble.
He was an unemployed architect living in New York in the 30's when he began devising a word game using letters printed on small cardboard squares. Butts called his game 'Lexiko' and there was no board involved.

It went unnoticed until 1948 when James Brunot thought it might have commercial possibilities. He and his wife began making the game in their home in Newtown, Connecticut. They settled on the name Scrabble.

The Brunots only sold 2,000 sets in their first year and sales remained sluggish until 1952 when the owner of Macy's store, who had played the game while on vacation, told the toy department to stock it. Other toy shops followed suit and the rest, as they say, is history.

FACTS FACTS FACTS

When the Queen Mother visited New York in 1954 she said she was fond of Scrabble, and former president Richard Nixon, claimed it was his favorite form of relaxation.

The Yo-Yo

In the 1920s, Pedro Flores moved from the Philippines to the USA, where he worked as a bellhop at a Santa Monica hotel. During his lunch break he carved and played with wooden yo-yos. He started to draw a crowd so he soon started a company to make the toy, calling it the Flores Yo-Yo Company.

Donald F. Duncan, an entrepreneur, first encountered the yo-yo during a business trip to California. A year later, in 1929, he returned and bought the company from Flores, acquiring not only a unique toy, but also the magic name "yo-yo."

TRIVIA TRIVIA TRIVIA

"Yo-yo" is believed to mean "come-come" in Tagalog, but in reality the word for "come" is "halika".

Trivial Pursuit

On December 15, 1979, two friends, Scott Abbott and Chris Haney, started an argument about who was the better game player. To solve this quarrel, they decided to create a board game of their own. To help them develop the game, they enlisted the help of two more friends, Ed Werner and John Haney.

In February 1982, Trivial Pursuit was introduced in the U.S. for the first time. It took years before the game took off, but by the end of 1983, 2.3 million games had been sold in Canada, and a million more in the United States. In 1984, a record 20 million copies of the games were sold in the United States alone.

FUN FUN FUN

The initial 34 people who scraped together as little as $1,000 for five shares have made fortunes as Trivial Pursuit has become one of the world's No. 1 selling board games.

As of 2004, nearly 88 million Trivial Pursuit games has been sold.

The Student Cookbook
200 Cheap and Easy Recipes for Food, Drinks and Snacks
91-85449-11-3, Humor/Cooking, $ 9.95/Paper

The Mission
The Change-Your-Life Game
91-85449-06-7, Humor/Games, $ 9.95/Paper
This book is a real-life game that may change your life!

The Macho Man's Drinkbook
91-85449-08-3, Humor/Cooking, $ 19.95/Paper
The Macho Man's Drinkbook contains more than 150 recipes of the most
popular drinks accompanied by 60 color photos of exotic and beautiful,
topless women.

The Pet Cookbook
Have your best friend for dinner
91-974883-4-8, Humor/Cooking, $ 14.95/Paper
Domesticated Delicacies from Around the World

The Pornstar Name Book
The Dirtiest Names on the Planet
91-974883-2-1, Humor, $ 14.95/Paper
The coolest hardcore names in the business
Rename your lover, or your pet, your car or the stupid person at work in
the nom de plume of a pornstar!

Dirty Movie Quote Book
91-974396-9-X, Humor/Film, $ 9.95/Paper
Saucy Sayings of Cinema.
With over 700 saucy, sexy quotes from the funniest and most sordid films
ever produced. A movie quiz game in a book.

BLA BLA - 600 Incredibly Useless Facts
Something to Talk About When You Have Nothing else to Say
91-974882-1-6, Humor, $ 9.95/Paper
A Know-It-All's Handbook

Confessions
Shameful Secrets of Everyday People
91-974396-6-5, Humor, $ 9.95/Paper
Eavesdropping in the Confessional.

Cult Movie Quote Book
91-974396-3-O, Humor/Film, $ 9.95/Paper
A Film Buff's Dictionary of Classic Lines.
Over 700 memorable, movie quotes

The Bible About My Friends
91-974396-4-9, Humor, $ 9.95/Paper
Things You've Always Wanted to Know But Have Been too Scared to Ask.

The World's Coolest Baby Names
A Name Book for the 21st Century Parent
91-974883-1-3, Pop Culture, $ 7.95/Paper
A perfect name guide to spice up any baby shower name game.
Baby names aren't handed down anymore, and the coolest names
are as much from pop culture as from the Bible.

NICOTEXT wants YOU!

This is what I liked with this book:

This is what I didn't like with this book:

I want a catalogue (your adress) :

I want to receive an email now and then (your email):

My friend wants a catalogue (friends adress):

I want a million dollars: ☐ yes ☐ no

Next time, why don't you make a book about: